CENTRAL MANCHESTER PUBS

DEBORAH WOODMAN

AMBERLEY

About the Author

Dr Deborah Woodman is a Research Development Officer at the University of Salford. Her research is focused around the history of North West England; the role of drink in society; commerce and trade; and popular politics of the nineteenth century. She has taught history at the Universities of Huddersfield, Salford and Manchester Metropolitan University. Her books include *The Story of Manchester*, published in 2017, and *Manchester in 50 Buildings*, written with Paul Rabbitts and published in 2019.

Front cover above: Bronze statue of L. S. Lowry inside Sam's Chop House. (Courtesy to photographer Paul Husbands and Chop House owner Roger Ward)

First published 2022

Amberley Publishing
The Hill, Stroud
Gloucestershire, GL5 4EP

www.amberley-books.com

Copyright © Deborah Woodman, 2022
Maps contain Ornance Survey data.
Crown Copyright and database right, 2022

The right of Deborah Woodman to be identified as the Author of this work has been asserted in accordance with the Copyrights, Designs and Patents Act 1988.

ISBN 978 1 3981 0165 4 (print)
ISBN 978 1 3981 0166 1 (ebook)

British Library Cataloguing in Publication Data.
A catalogue record for this book is available from the British Library.

Typesetting by SJmagic DESIGN SERVICES, India.
Printed in the UK.

Contents

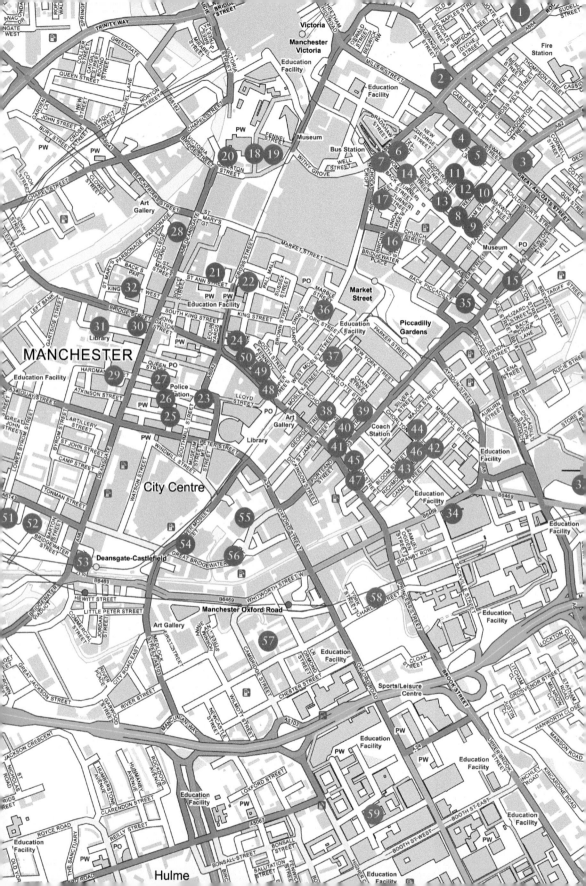

Key

Acknowledgements

There are several people and organisations that I would like to thank and acknowledge in the writing of this book. First, I wish to show my gratitude and appreciation for Roger Ward of the Manchester Chop Houses, who has been especially helpful and kind in offering information and photographs that have been invaluable in the production of this book. I also wish to thank Joe Gaskin of the Lass O' Gowrie for his photographs and enthusiasm for the project. There are many photographers on Flickr who have very kindly donated their images and responded to me with great enthusiasm, and these include Bernt Rostad, Canon Pete, Marie Turner, Phil King, Adam Bruderer and Ellen Thompson. I would like to show my appreciation for Mark Flynn of manchesterpostcards.com whose dedication to old postcards of Manchester is both fascinating and admirable. Thanks also to Manchester Local Studies and Archives and Chetham's Library for their timely help, even during a pandemic. The research for this book has largely been conducted utilising old newspapers and I commend the online British Newspaper Library and hope this resource grows from strength to strength. I am an avid user of old trade directories and have found these to be one of the most invaluable resources in reconstructing the development of Manchester over the last 200 years or so. Many of these have been digitised and I hope individuals and organisations manage to keep this good work up in allowing historical study, particularly since much of this book was written at a time when visiting archives was impossible. At least I could keep researching and writing! Finally, a great thank you to all the publicans and their hostelries, both past and present, who have made the story of pubs and their role in Manchester such a rewarding book to write.

Introduction

Manchester is a modern and cosmopolitan city that is home to a range of old and traditional public houses. Many of these establishments have retained their distinctive heritage, with some dating back to early modern times and many witnessing key moments in the city's fascinating past. Much of the research conducted here stems from the eighteenth and nineteenth centuries. In particular, the nineteenth century was a pivotal time for both Manchester's history and sweeping changes in drink culture both locally and nationally. Much of Manchester's working-class daily life outside the factory was centred around the inn, pub or alehouse, where one's 'local' was a focal point for sociability, a centre for transportation, discussing politics, business transactions, hosting friendly societies, and so on. Drinking, or more importantly drunkenness, became associated with class distinction and the lower echelons upsetting the social order, thus causing alarm to the middle and upper classes, who felt a pressing need to legislate to regain control. The 1830 Beer Act and the arrival of the beerhouse radically changed the nature of drinking both nationally and in the city. It was designed to encourage more beer drinking to offset the arrival of spirit vaults and alter alcohol consumption. Unfortunately, this ill-thought-through legislation backfired and led to the arrival of literally thousands of beerhouses since for a nominal fee you could gain a licence to sell beer and many set up shop in their front rooms. Since beerhouses were outside the control of magistrates, it led to problems monitoring their conduct. Manchester witnessed over 2,000 of these. Some closed as soon as they opened but many more obtained full public houses licences, especially by the second part of the century when legislation was introduced to mitigate their effects on the licensed trade and society in general. Throughout the century brewing giants began to monopolise the industry by mopping up hostelries in an ever-growing tied-house system, which affected the style and quality of pubs, and these effects can often be seen in pubs that have survived into modern times, mainly through their architecture and design.

It is important to note that there are many pubs in central Manchester and this book does not cover all of them – it is with a note of apology and sadness that they cannot all be included. All of the pubs listed in this book survive to date for us

to enjoy their heritage and ambience, but some that did not survive are worthy of mention and continue to have a special place in Manchester's past. The first of these is the Seven Stars, which claimed that it was the oldest licensed house in England. While this remains unverified, its provenance dates from the 1350s and it survived into the early decades of the twentieth century. If only it was with us today! Located in Withy Grove, it was on the site of the current Printworks leisure complex and indeed a Seven Stars pub still exists, if a more modern version of its predecessor. However, it is possible that the Rovers Return in nearby Shudehill could have been even older.

Two more pubs are worthy of mention. First, the Sun Inn was known as 'Poet's Corner', which was a popular venue for locals reciting their literary concoctions and bore witness to the local poet and radical campaigner Samuel Bamford, who was prominent in the radical working-class movements of the early nineteenth century and a participant in the infamous Peterloo Massacre, along with other local working-class literary specialists who met here to recite their works. The second was the Bull's Head Inn, located in what is now the Arndale Centre, which was a well-known meeting place for radicals and was a key place for discussion of politics in the area.

Fortunately, we have one survivor of early times and this is the Wellington Inn. It has not always been a pub and was originally a house. Its internal features, though it has been modified over the centuries, and has even been physically moved in the wake of the IRA bombing of Manchester in 1996, are still a close representation of its original architectural style. The surface area of land it occupies is small compared with more

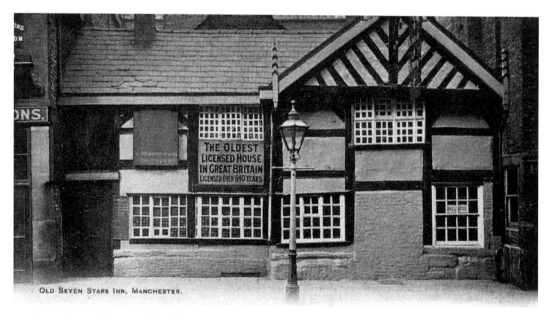

OLD SEVEN STARS INN, MANCHESTER.

The Seven Stars used to be located on Withy Grove and once claimed to be the oldest licensed public house in England.

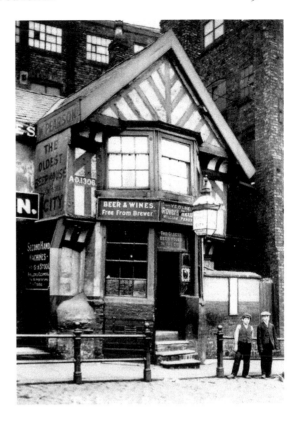

Right: The Rover's Return, which used to be on Shudehill.

Below: The Sun Inn, also known as 'Poet's Corner'.

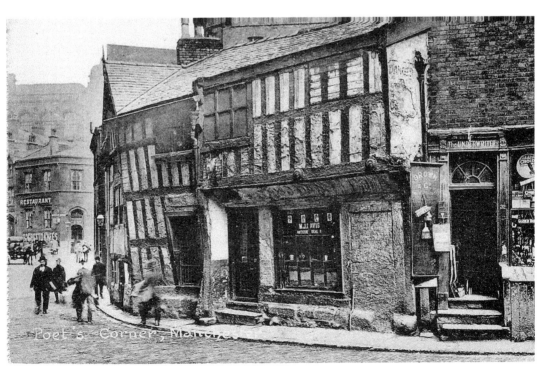

modern drinking establishments and it is narrow with three floors, low beams and small mullion windows, which are representative of its early modern origins.

Much of this book was written during the 2020 Covid-19 pandemic, which led to the closure of pubs, along with many other sectors. Despite the current climate of pubs regularly closing, and seeing who will survive 2020, the pub as an institution constantly reinvents itself and many of Manchester's often old-fashioned hostelries sit alongside modern offices and apartments since they still have such an important part to play in local life and the heritage of the city. By looking at individual pubs, this book will illuminate the reader to a novel aspect of Manchester's history based on the comings and goings of ordinary folk over the last few hundred years or so.

The Northern Quarter

The Marble Arch, Rochdale Road

The Marble Arch, and up until 2020 its sister pub, No. 57 Thomas Street, has been managed by the local Manchester Marble Brewery, which has been in operation since 1997. Originally the Marble Arch pub housed the micro-brewery, which provided a

The Marble Arch. (Courtesy of Bernt Rostad)

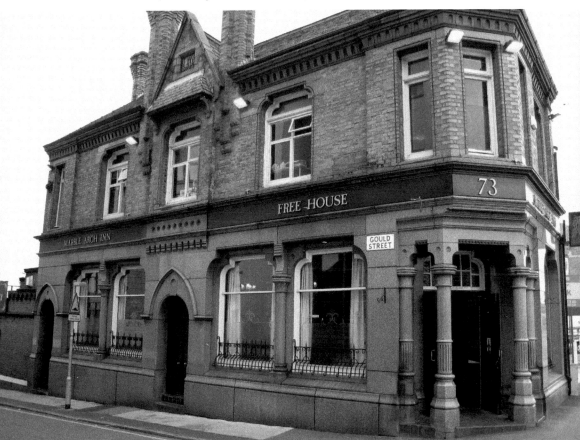

spectacle for drinkers who could observe brewing production in action. The brewery moved to larger premises in a local railway arch in 2009, continuing to produce their unique pale ales and stouts. In spring 2019 they moved again to larger premises in nearby Salford. The centre of the business, the Marble Arch pub, was Grade II listed in 1988. The current building dates from 1888, but there has been a pub on this site since around 1830. The building is an unusual brick and pink granite design, and its interior is a delight of original Victorian features, including an ornate Victorian mosaic floor, which has a distinct slope. Several suggestions exist as to why this is the case, including convenience for unloading barrels, a trap for dropped coins, and even an ideal setting for cheese rolling competitions! Before it was the Marble Arch, it was known as the Wellington Inn or Wellington Vaults and indeed photographs from the 1970s illustrate both its original name and its brewery, Wilsons, who acquired the pub in 1958. Previously it was managed by the local Harpurhey brewer B. & J. McKenna, who was subsequently taken over by Walker & Homfrays, who acquired McKenna's in 1905, followed by Wilsons, who acquired the pub through a subsequent merger with Walkers & Homfrays. In the mid-1980s CAMRA (the Campaign for Real Ale) purchased the pub and it became a free house. Into the 2000s it was acquired by Marble Brewery.

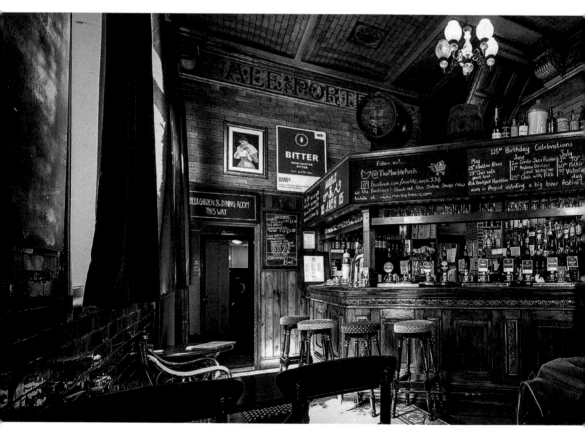

Inside the Marble Arch. (Courtesy of Canon Pete)

The Angel, Angel Street/Rochdale Road

Today, the Angel public house finds itself located on an inner-city ring road surrounded by modern apartments and offices. However, during the nineteenth century the pub, which dates from the early 1800s and was formerly known as the Weaver's Arms, was located in the notorious Angel Meadow district, which was a particularly poor and crime-ridden part of Manchester. One of the first known references to the pub is seen in the local newspaper the *Manchester Mercury*, which reported an auction at the Weaver's Arms, Angel Meadow, in 1808, and it was occupied by Samuel Walker.[1] We also know through trade directories that for around twenty years the pub was managed by the Gaskill family, first by Samuel who occupied the pub from around 1818 and we know that in 1826 his wife Ann died at the age of just twenty-seven. By 1828 it had been taken over by Thomas Gaskill, who occupied the pub until he died in 1842. Given the area in which the pub was located, it is no surprise that there are numerous newspaper reports of criminal activity in and around the establishment.

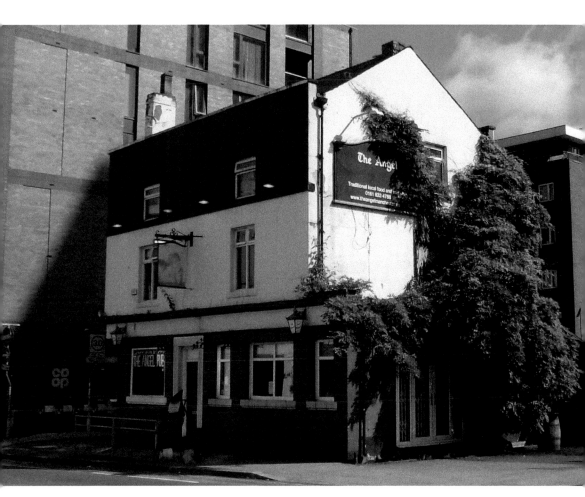

The Angel, surrounded by modern offices and apartments.

For example, in 1841 John Barlow was pickpocketed as he left the pub, and in 1853 William Fone was assaulted and robbed on leaving the establishment.[2]

The pub remained the Weaver's Arms into the twentieth century. More recently it became 'The Beer House' but closed in 2006, reopening as a gastropub called the Angel Inn in 2008. Today, the Angel has managed to survive demolition despite the surrounding redevelopment of Angel Meadow that has turned one of the poorest areas anywhere into a desirable city centre place to live and work.

The Crown & Kettle, Oldham Road/Great Ancoats Street

At the corner of the very busy junction of Oldham Road and Great Ancoats Street, the Crown & Kettle is an imposing establishment that was brought back to life after a period of closure for some sixteen years, reopening in 2005. It is believed that there has been a pub on this site from the early eighteenth century, and during the nineteenth century was once a locality associated with Manchester's working-class culture and radical political life. Manchester historian of the early twentieth century Thomas Swindells records in his history of the city how 'at the right-hand corner of Newton Lane stands a two-storied double-fronted cottage, which we are told in a footnote was an alehouse with the curious designation of "The Iron Dish and Cob of Coal", a sign as peculiar as any of which we have record in Manchester'.[3]

By the 1790s, the Crown & Kettle had appeared on the site, where the first known record of the pub's existence was an advertisement in the *Manchester Mercury* newspaper during 1796 reporting a forthcoming auction, and where it was occupied by a Mr Knowles.[4] During the early nineteenth century, Manchester was a volatile place. Working-class people faced poverty and demands for a political voice, and often meetings to discuss such issues occurred in pubs. The Crown & Kettle was one such place and often at the centre of a 'cat and mouse' situation between customers and the authorities who were keen to break up seditious gatherings in pubs. One such incident was seen in April 1812 where the *Manchester Mercury* reported how some windows were broken at the pub as part of wider disturbances in the area.[5] In 1819, just six days before the Peterloo Massacre, on 10 August, the pub was reported in the local press once more, and by this time it is clear the pub had become a well-known place for underground political activity. Here the article states:

> Twelve pence half-penny a week, aye marry and a goodly addition to a poor man's wages. For this he may get we'll say, a six-penny loaf, a sup o' beer and a bit o' comfort at the Crown and Kettle out of the Observer, and give his penny a week besides to support the reformers in making speeches and living like gentlemen...[6]

Architecturally, the Crown & Kettle is an ornately designed establishment, with a dramatic ceiling and chandeliers. Such architectural attention to detail has led some to believe that the pub was intended for legal purposes, such as a courtroom. In 1961 it was taken by Wilsons Brewery until its closure in the late 1980s. Up to this point, it was just a couple of doors away from the *Daily Express* printing press and offices and many of its clientele were associated with journalism. By this time, the pub

The Crown & Kettle. The nearby buildings were once home to the *Daily Express* newspaper.

was facing some challenges, in particular problems with disruptive football fans. It remained closed for sixteen years, and despite becoming a Grade II listed building in 1974 it suffered the effects of vandalism. The former *Daily Express* building, which is an interesting art deco design construction, has more recently been turned into offices and apartments. The Crown & Kettle reopened in 2005 and remains a thriving part of Manchester's pub heritage.

Smithfield Market Tavern, Swan Street

Named after the former Smithfield Market that surrounded the pub, the area was a vital trading centre for food supplies during the nineteenth century, and the pub was in a key position for traders. During the 1790s the site was occupied by Thomas Coop, who owned a loom maker business, but the Smithfield Tavern can be traced back from 1824, occupied by Abraham Taylor at No. 1 Coop Street (which runs at the side of the pub to the former market). In 1834 Isaac Middleton, landlord of the Smithfield Market Tavern, was in front of local magistrates for selling spirits, which was outside of his licence conditions. He had converted part of the house into a spirit vault and neighbours were complaining of it being a nuisance. However, despite him breaching his licence, opening spirit vaults had become common practice in the earlier part of the nineteenth century since many publicans were responding to increased competition from beerhouses, which had emerged from 1830 following the arrival of the Beerhouse Act of that year. Taylor

was fined £5 plus costs and he subsequently reapplied for a full licence. Unfortunately, in the interim, he had to revert the vault to its original shop premises until the correct licence had been granted. We gain further glimpses into the daily life of the pub since in 1849 an advertisement in the *Manchester Times* described the pub as having an attached brewhouse, a popular feature among many pubs at this time, where many landlords brewed their beer on-site, and before the development of large-scale brewing.[7] We also know that in the 1840s the pub was adjoined to a fishmongers' shop.

Turning to the twentieth century, in the 1970s the Smithfield Tavern belonged to Groves & Whitnall Brewery. Into the 2010s it has subsequently been owned by a small local brewery, Blackjack Beers, that began business in 2012. The brewery is located close to the Smithfield Market Tavern, housed in a railway arch in nearby Angel Meadow. As we have seen with the nearby Angel public house, Angel Meadow has had a modern renaissance in urban development but in the nineteenth century was particularly notorious. Blackjack Brewery also runs the Jack in the Box venue, located at the opposite corner to the Smithfield Market Tavern in what was once the old Smithfield Market meat market, which is now a Grade II listed building that has recently been renovated and opened with a new purpose.

Rose & Monkey, Swan Street

Next door to the Smithfield Market Tavern is the Rose & Monkey, which until 2019 was known as the Burton Arms. Consequently, it shares a very similar heritage to its neighbour. Maps of 1850 indicate that the site was the location of the John O'Groats public house. Its name has changed several times over the years. For example, in 1841 it was known as the Grapes until the late 1840s when it became the John O'Groats

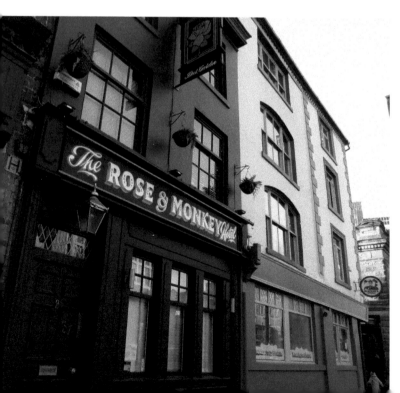

Rose & Monkey
next to the Smithfield
Market Tavern.

and then reverted to the Grapes until around the 1890s when it became the Burton Arms, run by Jane Eliza Taylor. In more recent times it was, from the 1970s to the early 1990s, a Bass Charrington pub. It subsequently became a Theakston's pub, but is currently a free house and was renamed in 2019.

Hare & Hounds, Shudehill

Like the Lower Turk's Head, the Hare & Hounds just a few doors away, with its unusual mottle blue-grey tiled exterior, is again a pub of both local and national historical importance. The pub can be traced back to the late 1780s where it was managed by Timothy Wood. Like the Lower Turk's Head, it had a key position in front of the busy and notable Smithfield Market. This pub was a key centre for transportation during the nineteenth century, servicing locations around Saddleworth, such as Austerlands, Delph and Dobcross. It was popular among manufacturers visiting the Manchester markets, with predominantly fustian manufacturers from parts of Oldham and Saddleworth visiting each week. It was also a place where you could book trips on canal packet boats to Southport and Liverpool. In June 1836, the Hare & Hounds was badly damaged by a fire, which started in the dining room in the early hours of the morning at the premises, that destroyed most of the front part of the interior.

Into the twentieth century, the pub was renovated in 1925 and was Grade II listed in 1999. It retains a distinct Manchester Victorian interior reminiscent of its location and industrial past. It formerly belonged to Tetley's Brewery in the 1970s but is currently a free house, mainly serving local brewer Joseph Holt's beers.

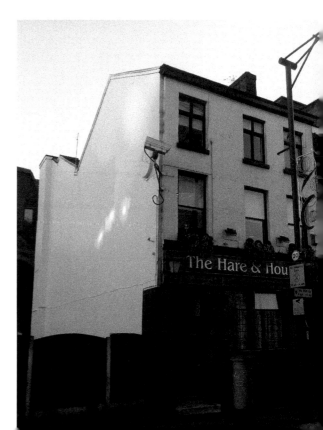

Hare & Hounds, with its distinctive exterior tiling.

Lower Turk's Head Hotel, Shudehill

The Lower Turk's Head was named as such to differentiate it from the Higher Turk's Head that used to exist further along Shudehill and both pubs had key positions in their proximity to the busy and notable Smithfield Market during the nineteenth century. The Lower Turk's Head is believed to have existed here since the 1740s, though firm evidence of the pub's existence can be found from the 1780s, where the 1788 trade directory records both Turk's Head pubs as the 'old' and 'new'. In 1794 they were recorded as the 'Lower' run by James Collier and the 'Higher' run by Thomas Emery. During the nineteenth century, the Lower Turk's Head was a centre for transportation where coaches to places like Oldham, Rochdale, Ashton-Under-Lyne and Bacup used to operate. Therefore, it is no surprise that manufacturers came to the pub each week to trade, and most of these are recorded in trade directories as predominantly fustian manufacturers mainly from Oldham and the surrounding area.

The letters 'MB' above the door signifies that during the late nineteenth and early twentieth century it was owned by the Manchester Brewery Company. By the 1970s and through successive brewery takeovers so prevalent at the time, it was managed by Wilsons Brewery. In recent times the pub was closed in the 1990s for around twenty-two years until its refurbishment and reopening in 2013. Currently run by Manchester Brewery Ltd (a different company to the original Manchester Brewery), the Lower Turk's Head is linked to the Scuttler's Wine Bar next door. This bar is named after the Scuttlers, who were infamous youth gangs that used to parade the streets of Manchester to violently compete for prestige and territory.

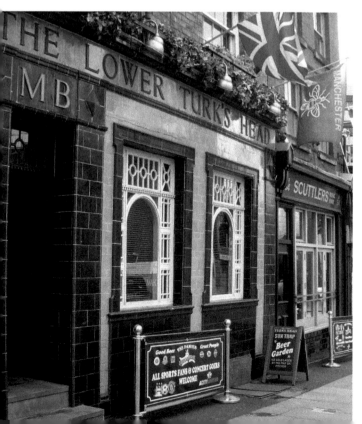

Lower Turk's Head with the adjoining Scuttlers Bar.

Gullivers, Oldham Street

Refurbished in 2014, Gullivers is currently managed by J. W. Lees Brewery and is a vibrant city centre pub whose upper floor offers live music with two main spaces, one that contains a stage and offers space for around 100 and a smaller space for more intimate musical offerings. Gullivers is very much rooted in the artistic community of the Northern Quarter of the city, with a range of film, music and other events taking place most nights.

Initially, the building was a private residence from the end of the eighteenth century. It is believed that it became licensed around the early 1820s and by 1834 it had become the King's Arms & Coronation public house managed by Arthur Peters. In the early 1860s, it was known as the Queen's Stores, which was run by William Frith. By 1864 James Ramwell takes over the Queen's Vaults, and at some point during his management, he changed its name to the Albert Hotel. Ramwell took on the pub in a poor condition, which also contained a cottage that had been a beerhouse and an on-site brewery, and subsequently made some alterations, including the addition of a vaults. However, he ended up facing court because he had made alterations to the premises without proper consent. He was eventually granted his licence, in part because the former pub had acquired such a bad reputation that Ramwell's improvements to the premises only helped to raise its standards.[8] By this time the pub occupied the site from Oldham Street through to Tib Street at the rear as one property, since previously it had been two separate premises. In December 1870 James Ramwell caught the attention of the law again when he was sentenced to pay a fine of £5 or suffer two months imprisonment for stabbing a bailiff, Richard Hibbert, who had been put in

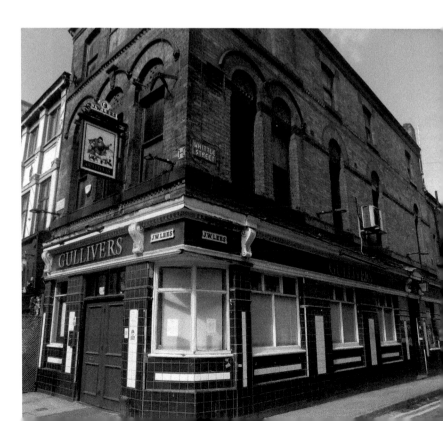

Gullivers.

possession of Ramwell's premises.[9] By January 1871 Ramwell had left the pub and William Parsonage had taken charge. He was not at the pub long since the licence transferred to Vincent Crawshaw in April 1871.

It retained its name as the Albert for over a century into the twentieth century. It was subsequently managed by Wilsons Brewery until the 1970s and renamed the Grenadier before J. W. Lees Brewery purchased the pub from Wilsons Brewery in the 1970s and renamed it Gullivers.

The Castle, Oldham Street

The Castle is a distinctive Grade II listed pub, noted for its exterior brown-glazed tiles that were a signature of the former Ardwick-based Kay's Atlas Brewery that once owned the pub. It is believed that the building has existed since around the 1770s and, like Gullivers, was initially a private residence. It is currently at No. 66 Oldham Street but during its early life the building was at No. 76 and here we see that in 1794 Benjamin Davies was managing a Bull's Head at No. 76 and is recorded as a victualler and dyer, demonstrating that it was common for pub landlords to have more than one occupation. By 1800 the premises had become the Talbot Tavern, managed by John Spencer, but we see evidence from the 1794 trade directory that the Talbot Tavern run

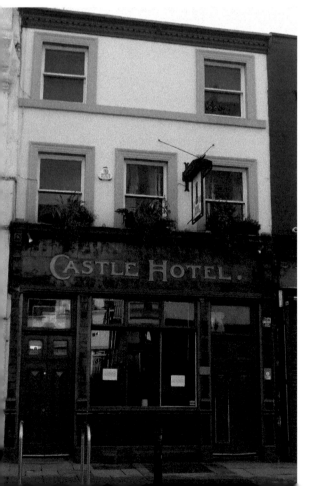

The Castle Hotel.

by Spencer was the at No. 18 Hilton Street and he appears to move his premises to the Oldham Street site. The premises on Hilton Street remains a pub that ultimately became the Crown & Anchor from around the 1820s. From 1869 onwards the Oldham Street pub was named the Clock Face until it changed to the Castle Hotel by 1911 when it was run by Arthur Leggett and Kay's Brewery acquired the pub. In 1915, the Castle became the centre of a spot of bother when the landlord was convicted of 'harbouring disorderly women' and fined £5.[10] This led to concerns over the renewal of the pub's licence, since in 1912, under the management of Richard Spencer, the Castle was regarded as too disorderly, though its licence was renewed on condition that the music licence was revoked. Unfortunately, this condition was breached, and Richard Spencer was fined 20s.[11]

Kay's Brewery was acquired by Stockport-based Frederic Robinson in 1929 and the Castle has retained links to Robinson's Brewery ever since. In recent times the Castle briefly closed in 2008 but has had something of a revival thanks to former Coronation Street actor Rupert Hill and colleague Jonny Booth, who reopened the pub in 2009, and by 2010 a music hall was opened that can house eighty music goers.

The City, Oldham Street

The City pub has reminiscences of early modern architecture with its exterior panels, one that depicts the arrival of King William and Mary of Orange, who arrived in England in 1688 and deposed James Stuart to take the crown, and a top relief panel containing royal arms with a lion and unicorn. During the 1780s the site of the City pub was owned by Arthur Glegg and Samuel Loaff, who were both in the timber trade. They leased some of their land where a couple of properties were built. Like other pubs at the top end of Oldham Street, the City was initially a private house from the 1780s and became a public house by 1800, at one time known as the Prince of Orange and then the Prince of Gloucester.[12] In 1804 William Aldridge is recorded as the landlord for Prince William of Gloucester. The establishment had connections to the Irish Orange Order and its former name of the Prince of Orange is likely to have reflected this. There were riots in 1807 and again in 1830 where Catholics attacked public houses where Orange lodges met, and the City was a target of these.

Later into the nineteenth century, maps and trade directories of 1850 record the pub as the King's Arms Vaults managed by John Turner at No. 133 Oldham Street, which was directly behind No. 112 Tib Street. In 1854 Edward Todman announces his arrival at the King's Arms in local newspapers.[13] By 1869 the pub was being managed by Peter France, but the property at the rear had become a separate beerhouse run by Joseph Woolfenden. The two properties remained separate until the 1890s when it became one establishment from Oldham Street through to Tib Street, by this time managed by John Davison and was known as the Top King.

The pub was purchased by Chesters Brewery in 1914. In 1970 Thelfalls Brewery, which had merged with Chesters Brewery in 1961, took control and following renovations the pub became the City. After a brief spell being owned by Whitbread between 1991 and 1992, it was purchased by Moor Inns Limited, owned by Armstrong

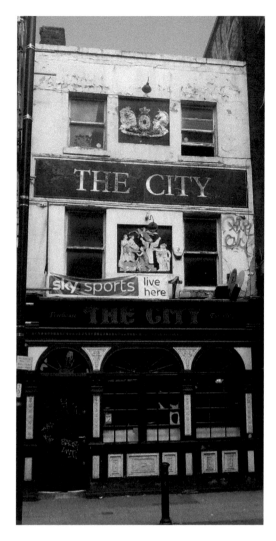

Left: The City.

Below left and below right: The friezes above the door of the City.

Brewers, but by 1995 it had become a free house. Roy Dutton, who has written much on the history of the pub, purchased the pub in 1995 but sold it in 2000. In 2009, manageress Joan Howard was fatally injured following a fire at the pub, which reopened after a fifteen-month closure.[14]

The Wheatsheaf, Oak Street

The Wheatsheaf is situated in the heart of the former Smithfield Market, in particular the old fish market, and in a good location to support market traders in the locality. Dating back to the 1790s, it was originally known as the Fleece. Like many pubs of the time, the establishment held important community functions aside from their routine business of drink. The importance of its proximity to the Smithfield Market is exemplified in the Lincolnshire *Stamford Mercury* in 1822 where 'beast and sheep' salesmen from Leicestershire were advertising their presence at the Fleece Inn, who used the pub as a contact point for messages in between their Wednesday visits to the market each week, emphasising the role of pubs in the nineteenth century in the local economy and life of the city.[15] By 1834 the Fleece had become the Butcher's Arms but by 1847 had reverted to the Old Fleece, reflecting its earlier heritage. It has been

The Wheatsheaf.

Mural on the side of the Wheatsheaf.

known as the Wheatsheaf from the 1860s to the present day. Into the twentieth century, it belonged to Tetleys Brewery from the 1970s through to the 1990s. In 2019 a large mural of an old bus was painted on the side of the building, which provides a unique perspective of the pub from Tib Street.

Tib Street Tavern, Tib Street

This establishment is a relative newcomer to the Northern Quarter, opening in 2012 after a major refurbishment and following on from its previous incarnation as the Café Centro. Tib Street has been home to an eclectic mix of business over the years, from textile manufactures and warehouses, and its proximity to Smithfield Market in the nineteenth century. In the 1970s it was famous for its livestock and pet shops, and more recently it has become well known for its proximity to the famous retro fashion outlet Afflecks Palace.

As we wind back to the origins of the Tib Street Tavern's premises, we know that in 1850 Nos 72 and 74 Tib Street was a hairdresser and a painter, respectively, in 1863 a shop and a chair maker, and by the 1870s, John Hobson's boot and shoe manufacturers. During the 1890s it was a warehouse trading in surplus and fire-damaged stock, mainly clothing and other textiles. By 1895 it was occupied by the Beaty Brothers, who had other premises on Oldham Street. In 1940 it was a warehouse run by Beales, and in the 1950s the premises were occupied by Westwell & Co., a textile and shipping merchant. The modern Tib Street Tavern offers both the traditional and modern, where its refurbishment of 2012 stripped the building back to its original brickwork and added modern features that have somehow retained and enhanced its heritage, with a local historical edge to it. Its interior is decorated with local scenes from the 1950s and is instantly recognisable from the outside with a moped in the window.

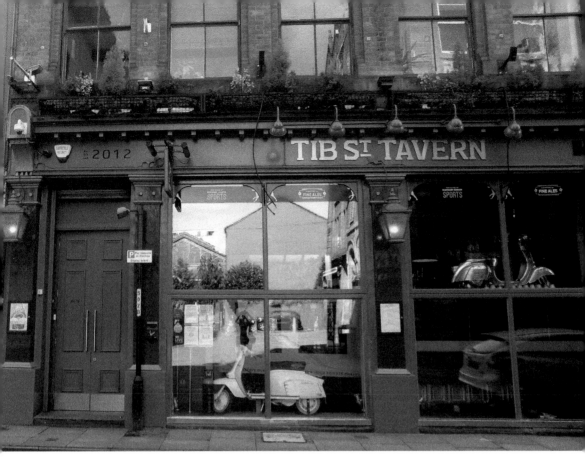

Tib Street Tavern.

The Millstone, Thomas Street

This J. W. Lees pub dates from around the turn of the nineteenth century and its first appearance in the local press was an 1808 edition of the *Manchester Mercury*, which advertised an auction at the pub.[16] In 1817, the premises were for let and here, like many pubs of the time, it included an on-site brewhouse.[17] By 1840 it had changed its name to the Roebuck but maps of the mid-1840s illustrate that it had changed back to the Millstone & Fountain Inn. Like many establishments of the nineteenth century, it provided a means for the working class to meet and indeed the pub had a large room that could accommodate such gatherings. For example, in September 1849, there was a meeting where several local branches of factory operatives discussed wages. Other meetings the pub hosted included discussion of municipal elections, the Irish Electoral Association, Manchester and Salford trades council and other professional bodies.

The Millstone has had its share of tragedy over the years. In 1856, James Mallertt, a mechanic's labourer, suddenly died in the lobby of the pub. Even more shocking was the case in 1899 of the thirty-five-year-old publican Charles Wilson, who was found dead in bed having shot himself. It appears that he had suffered poor health following an operation and took his own life. In 1884, the landlord, James Lynch, was charged with permitting betting on the premises. He was caught in a sting operation by two

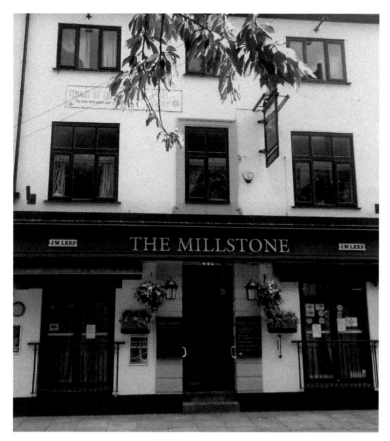

The Millstone.

undercover police officers who witnessed a customer giving some money to a waiter to wager a bet on some horses. Between 1888 and 2004 Wilsons Brewery managed the pub until it was acquired by J. W. Lees. It was refurbished in 2014 and remains a traditional pub in the heart of the Northern Quarter.

Bay Horse Tavern, Thomas Street

The Bay Horse is one of the oldest known pubs in the city and its heritage can be traced back to the end of the eighteenth century, and we know that in 1794 it was run by John Shepley and in 1797 by Edward Waters, who was still at the premises at the turn of the nineteenth century. In 1806 the *Manchester Mercury* newspaper advertised an auction of the premises since Edward Waters had recently died and his wife had taken over the pub.[18] The description this provides gives us insights into the life of the establishment, where it offered two parlours, a newsroom, which was a place where customers could access newspapers either by reading themselves or where 'readings' took place for the illiterate, and a large club room. Like many establishments, it also contained an on-site brewhouse, stabling for five horses and even sleeping quarters specifically for soldiers that were located above the kitchen. It was popular among factory workers, and, like many pubs of the time, hosted building societies and other

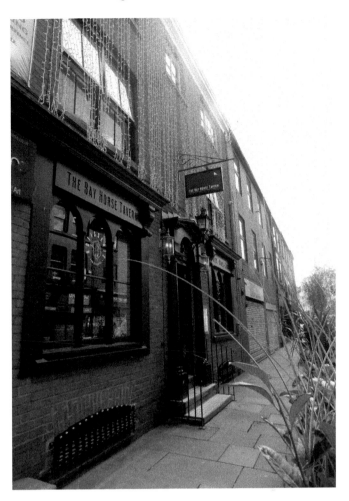

The Bay Horse Tavern.

friendly and benefit societies. For instance, there was a report in an 1826 edition of the *Manchester Courier* that a steward of a building society hosted at the pub was charged with obtaining deeds that were held as security on payment advances from the box kept at the premises.[19]

The Bay Horse was managed by Chester's Brewery up until 1900. More recently it was managed by Bass Brewery in the late 1950s and was acquired by Wilsons Brewery in the 1970s. It faced devastation in the 1990s when it was heavily damaged by fire but was rebuilt and retained its name. It faced further renovations in 2017 and is currently known for its range of gins and craft beers.

Crown & Anchor, Hilton Street/Port Street

The Crown & Anchor is another of Manchester's oldest pubs. It currently resides at No. 41 Hilton Street, at the corner with Port Street, but as with many buildings over time, door numbers change, which affects the historians' ability to trace a particular establishment. The earliest traces of a pub on the site is that of John Spencer's Talbot

Tavern in 1792. Trade directories of 1797 record a Talbot Tavern at No. 18 Hilton Street, occupied by John Spencer, who, as we saw earlier, was recorded at a Talbot Tavern at No. 76 Oldham Street by 1800, the site of the current Castle public house. The next record is an auction taking place at the Crown & Anchor in 1806 where Richard Ollis had been declared bankrupt and the contents of the pub were being sold off.[20] It was subsequently occupied by the Bake family since we see John Bake occupying the pub around 1817 until the early 1820s and Thomas Bake from 1824 until around 1841. In 1817, landlady Martha Bake was in the news as a witness in a murder trial, where four men were on trial for the murder of two women in Pendleton, and who had visited the pub prior to the crime being committed. The pub had hosted the United Friendly Building Society from the 1830s and in 1862 landlord John Holt was found bankrupt and there were suspicions of foul play with the accounts. Holt lasted about a year at the pub after this became public knowledge, when John Biddolph took over in 1871. There was a further case of financial impropriety in 1867 when a customer, Joseph Atkinson, claimed some money by false pretences from the building society. The pub was under the management of Chester's Brewery from the 1880s until the 1970s. Today it is managed by the EI group. It is also home to Manchester's social chess club.

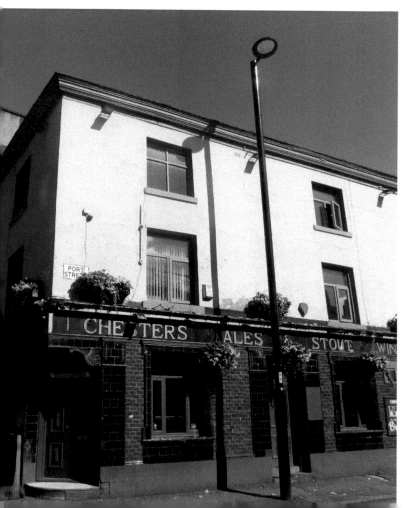

Crown & Anchor.

The Unicorn, Church Street

The original Unicorn public house dated back to around 1810 and became a popular venue for manufacturers and merchants from the surrounding town to visit the Manchester markets, particularly on Tuesdays. The establishment became a key place at the heart of the warehousing district around High Street. A dining club was established and over the next few years, it became more formalised and known as the Scramble Club. The club, founded by local Tory politician Jonathan Peel, of the Peel political dynasty, was attended by some prominent merchants, many of whom eventually held political and public office, and its name was coined to reflect the mad rush at lunch between trading sessions. The Unicorn became known affectionately as Old Froggatt's after landlord Henry Froggatt, who offered fourpenny pies and ale. Over time the regulars clubbed together to provide a joint of meat – a penny for cooking and two pence for catering, and indeed Old Froggatt's wife prepared this every week. The club was there for some years before moving to the Clarence Hotel in Spring Gardens around 1848. In the 1840s the pub also hosted the Unicorn Building Society. The current establishment, constructed in 1924, was Grade II listed in 2019, owing to its rare interwar architecture, designed with a traditional oak-panelled interior. A former Bass Charrington pub, the Unicorn currently offers a traditional pint on the edge of the Northern Quarter.

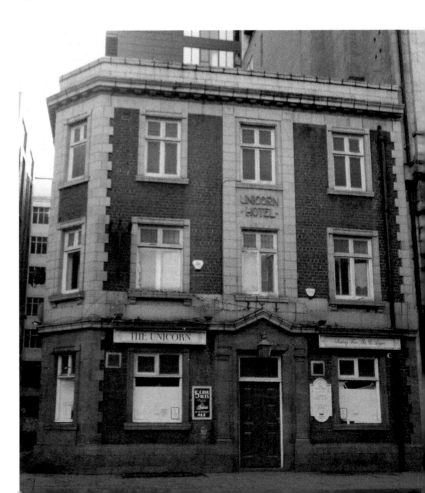

The Unicorn.

The English Lounge, High Street

The English Lounge, formerly known as the Wheatsheaf Hotel, is one of the oldest licensed premises in Manchester and is located at the edge of the Northern Quarter, opposite the Arndale shopping centre in High Street, which is one of Manchester older highways and can be seen on maps dating back to the early 1700s. During the nineteenth century it was in the heart of Manchester's warehousing district, where much of the city's commercial activity took place, particularly on Tuesdays when many country manufacturers came into Manchester from the surrounding areas to trade. During the 1880s it had become the Wheatsheaf Commercial and Family Hotel. In 1882 the building was lucky to survive when the roof collapsed on the four-storey premises. The building was undergoing renovations and it was believed that the poor quality of the work may have exacerbated an already weak structure.[21]

The pub was known as the Wheatsheaf Hotel until well into the 1970s when it was renamed the Hogshead, followed by Bensons between the 1970s and 1990s. It became the English Lounge in the early 2000s and continues to be a popular venue on High Street.

The English Lounge, formerly the Wheatsheaf Hotel.

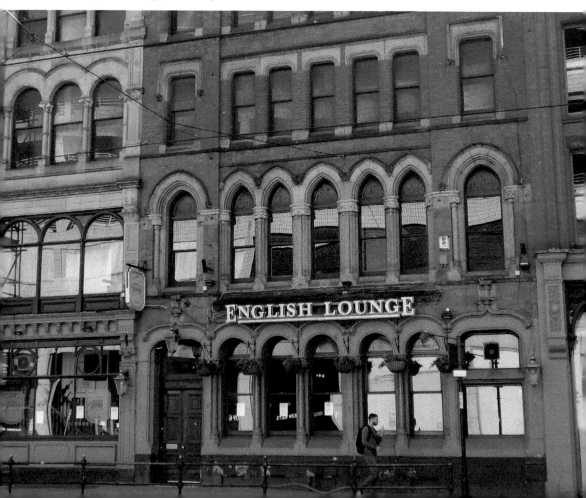

2

Cathedral Gates to Albert Square

Wellington Inn, Cathedral Gates

The Old Wellington Inn and adjoining Sinclair's Oyster Bar are two of the most iconic Grade II listed public houses, and indeed buildings, in the city. The Wellington Inn was believed to have been constructed as a house around 1552 in a small thoroughfare just off Market Street known as the Shambles. Downstairs, it became a public house but

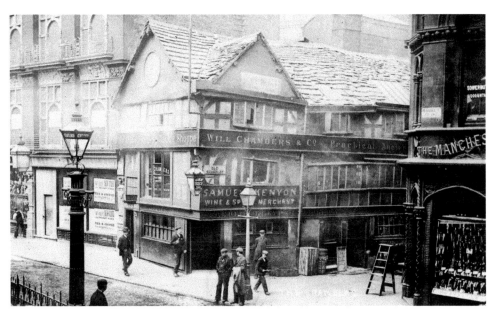

The Wellington in the early twentieth century. (Courtesy of Mark Fynn, manchesterpostcards.com)

throughout much of its early life, it contained a separate business on the upper floors, including a drapers, an opticians, and 'ye olde fishing tackle shoppe' at different times. During the seventeenth century, it was the home of the Byrom family where notable poet John Byrom was believed to have been born in 1692. It was originally two storeys high but during the seventeenth century an additional floor was added. Into the nineteenth century, specifically in 1827, James Willmot took a former fishmongers business and turned the premises into the Vintner's Arms public house. By 1850 it had become the Wellington Inn, occupied by James Ridyard. In 1869 James Kenyon had taken over and 1870s pictures from the time show Kenyon's wine and spirit merchants next to the Wellington Inn. By 1883 Samuel Kenyon had taken charge.

In modern times the Wellington Inn has faced some major challenges, notably surviving bomb damage both in 1940 during the Second World War and the 1996 IRA bombing of Manchester city centre. During the developments of the 1970s, a time when the preservation of heritage was not a key priority, the pub was consumed by the construction of the Arndale Centre and the inn was raised on a concrete platform to fit in with the wider redevelopment.

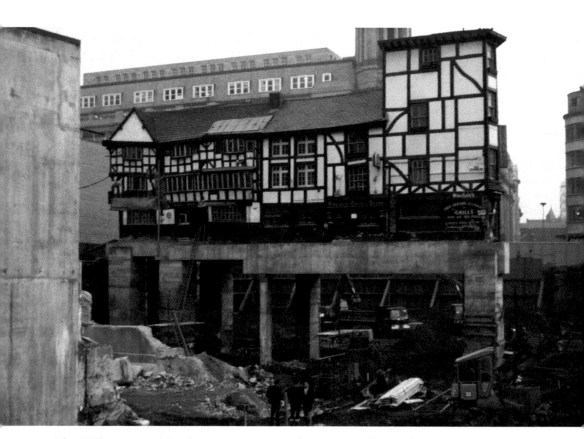

The Wellington and Sinclair's Oyster Bar in the 1970s as the Arndale Centre was being built around it. 'The Shambles Being Lifted Up'. (Mrs Newbold's Collection courtesy of Chetham's Library)

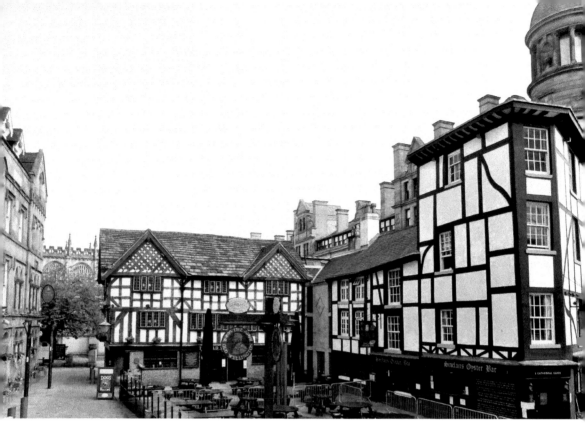

The Wellington Inn and Sinclair's Oyster Bar today, with Manchester Cathedral in the background.

Sinclair's Oyster Bar, Cathedral Gates

The building that adjoins the Wellington Inn and houses Sinclair's Oyster Bar is believed to originate from the 1700s and it contains original features that suggest it was a former chop house during the early nineteenth century, and is considered to be one of the oldest oyster bars and chop houses in England. It once housed a punch house occupied by proprietor John Shaw and his assistant, Molly Maid, and today John Shaw and Molly are depicted on the exterior inn signage. It was during the eighteenth century that John Shaw ran his punch house in the Shambles where many local merchants met after a day's trading and consumed his infamous punch drink. Shaw died in 1796, but the club which bore his name lasted until 1938, and it moved from pub to pub during its life. Molly Maid was infamous for removing customers that outstayed their welcome with her mop and bucket! There is a plaque commemorating John Shaw on the outside wall of nearby St Ann's Church, where he and his family are interred. Following Shaw's death, the Punch House was managed by Peter Fearnhead until it was sold in 1806 to William Goodall and the pub became the King's Head. It later became known as Sinclair's, then Sinclair's Oyster Bar, presumable because of its proximity to the local fish market also located near the Shambles.

Both pubs are currently located at the side of Manchester Cathedral, but this was not always the case. After the IRA bombing of 1996, both establishments were

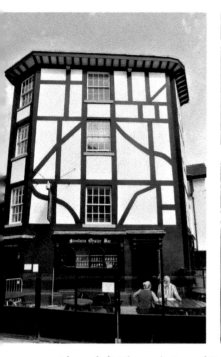

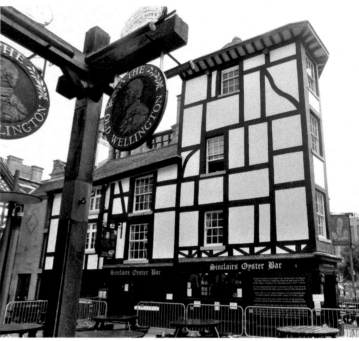

Above left: The end view of Sinclair's Oyster Bar.

Above right: Sinclair's Oyster Bar main entrance.

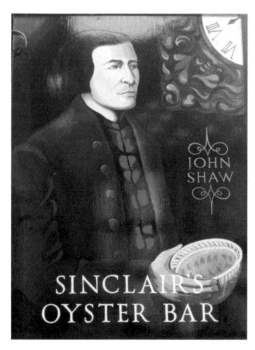

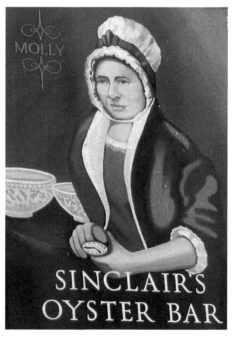

Above left and above right: Sinclair's Oyster Bar sign depicting John Shaw and Molly Maid.

systematically taken apart and relocated in the newly formed Shambles Square, reopening in 1999. Today, Sinclair's Oyster Bar adjoins the Wellington Inn in a vibrant and modern Shambles Square.

Crown & Anchor, Cateaton Street

Cateaton Street is one of the oldest thoroughfares in Manchester, visible on maps of the area from 1650. A few yards from the historic pubs in Shambles Square is another of Manchester's old establishments in the historic heart of the city and close to the cathedral. The earliest evidence of the Crown & Anchor's existence can be found during the early 1770s where it was then known as the Blackmoor's Head, located at No. 6 Cateaton Street, and occupied by Thomas Barlow. By 1781 his wife, Grace Barlow, had taken over management of the pub. It remained in the same family for some time and Grace was still at the pub in 1790.

The 1790s was a turbulent political time in the city. Manchester had become a politically and religiously divided place that had stemmed from events on the continent, notably the French Revolution of 1789. Political and religious factions were often played out in local inns, highlighting the divisive nature of politics and society of the time. The Blackmoor's Head was one such pub at the centre of the political turmoil and during the 1790s. By this time Matthew Green was the landlord and it was apparent

Crown & Anchor.

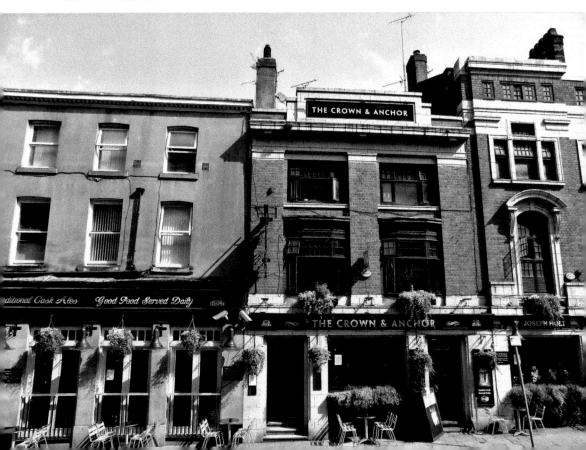

that he allowed politically motivated meetings in his pub, since there were numerous press reports of the 'loyal association' meeting at the establishment. This was a group that met in support of the king and government and upholding the constitution of the time, in opposition to groups such as the Levellers, who were demanding political reform. By 1818 trade directories record a Crown & Anchor and Blackmoor's Head as two separate pubs, with the Crown & Anchor facing onto Cateaton Street and the Blackmoor's Head overlooking Cathedral Yard at the rear. However, by 1840 only the Crown & Anchor was evident.

Into the twentieth century, the pub was part of Threlfalls Brewery in the 1960s and after resulting brewery takeovers, it was acquired by Chesters then Whitbreads breweries. By the 1990s it became Mr Chester's Pie and Alehouse before Joseph Holt Brewery took control and has been managed by Holts ever since. The original pub has expanded into premises on either side over the years, including that of the notable fine butcher's shop, James Brown, that had been there since the turn of the nineteenth century.

Looking up Cateaton Street, with Crown & Anchor and Sinclair's Oyster Bar in the background.

Manchester's Chop Houses

There are two chop houses within a few minutes walk from one another that are currently run by the same company but each with a unique style and history. A chop house was originally a hostelry that was part public house and part restaurant. Their origins date back to the sixteenth century when commercial trading was a vibrant part of city life and became popular in London and other cities, particularly among the wealthier in society, where merchants could dine and conduct business affairs. Manchester's chop houses are managed by the Victorian Chop House Company, led by Roger Ward, and which includes Mr Thomas's (lately Mrs Sarah's) and Sam's, founded in 1867 and 1872, respectively, by two brothers, Thomas and Samuel Studd.

Mr Thomas's Chop House (and Mrs Sarah's Chop House), Cross Street

First, we shall look at Mr Thomas's, which fronts onto No. 52 Cross Street and at the rear overlooks St Ann's Church Yard at No. 3, with St Ann's Alley at its side. The Grade II listed building is a narrow four-storey building that was formerly a Georgian townhouse that has contained a range of businesses over the years. The ground floor became a chop and sandwich rooms in 1867, occupied by Thomas Studd. At the end of the nineteenth century, architect Robert Walker was

Below left: Mr Thomas's, also known as Mrs Sarah's Chop House.

Below right: Cross Street entrance to Mr Thomas's Chop House.

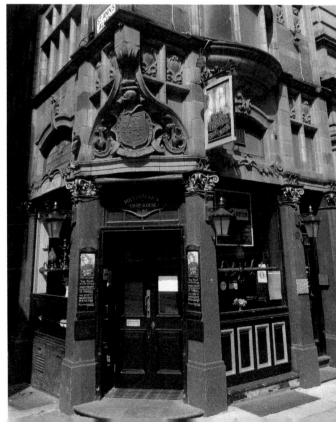

commissioned to redesign and enlarge the original premises, which was completed in 1901, and featured opulent Victorian interior architecture, with an ornate terracotta and Accrington brick exterior. The *Manchester Courier* of the time reported how the original chop house was replaced by an 'ornamental terracotta structure', and photographs clearly show its elaborate exterior.[1] This chop house was particularly convenient for traders and merchants visiting Manchester's cotton exchange just a minute or so away.

The businesses at the location have varied over the years. For example, in 1834 Thomas Samuels, a furniture painter, was located at the address, and in 1850 William Walker's printers and account bookmakers business, and a surveyor and estate valuer in the name of Mr T. Westall, was located there. Other businesses that can be traced are, in the 1860s, lawyers and private tuition. The local trade directory for 1877 records Thomas's Chop House and sandwich shop located in St Ann's Passage. By 1886 it had become Sarah Studd's chop and sandwich rooms, and Thomas's Chop House. Thomas was still the proprietor, but wife Sarah now had a visible hand in the business. By the early 1890s, John Studd had taken over as dining room proprietor, and Sarah

Below left: St Ann's Square entrance to Mr Thomas's Chop House.

Below right: Inside the chop house. (Courtesy of Marie Turner)

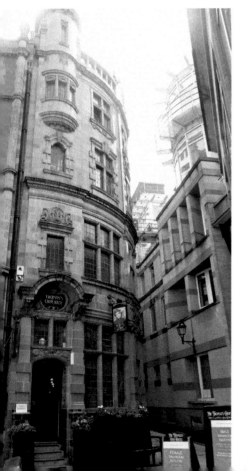
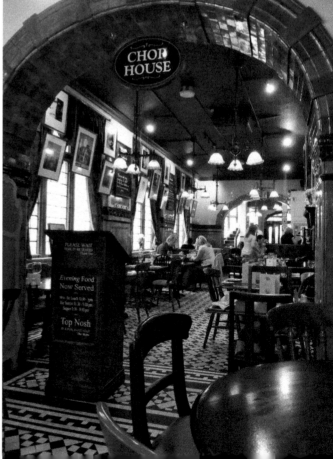

continued managing the rooms. In 1900 the licence for the chop house was revoked as it appears that Sarah had left the premises and there were plans to demolish and reconstruct the building. By 1911 there were six businesses at the address, including textile agents and solicitors, and the ground floor was occupied by Frank Willoughby, a wine and spirit merchants.

The *Manchester Evening News* in 1948 reflected upon the heritage of Mr Thomas's Chop House and revealed that 'businessmen of the day recall the days when the Street level floor was a long and spacious dining room, extending from the churchyard door to the Cross-Street door'.[2] During the Second World War, it was reduced in size but retained the Cross-Street part of the building, with the part overlooking St Ann's Square converted into the Manchester City Mission. In 2019 it was partially renamed in tribute and to include Thomas's wife, Sarah, who had been instrumental in its success, managing the business after Thomas died. It was subsequently taken over by their daughter, Sarah.

Sam's Chop House, Back Pool Fold

The second of Manchester's chop houses is that originally opened by Sam Studd, Thomas's brother. It is currently located at the corner of Back Pool Fold and Chapel Walks, just off the main thoroughfare of Cross Street, and occupies a site that goes below street level. However, it began its life elsewhere and was first recorded in the late 1860s as a dining room in Cockpit Hill, once located near Market Street and Corporation Street. It subsequently relocated to Manchester Chambers, still close to Market Street and nearby Pall Mall. It appears that Sam's was not licensed up to this point and there was a desire for alcohol to be served for the 1,500 or so diners that visited each week. By 1892 John Studd had taken management of both Sam's and Mr Thomas's. However, John also ran a turf accountant business and had previously done well out of this but by the early twentieth century, he found himself in financial difficulties and was declared bankrupt.

Sam's moved to its current address on the lower ground floor of a large building in Back Pool Fold, just off Cross Street, in 1963. The rest of the building has contained a range of businesses, such as shipping and estate agents, accountants and so on. By this time it was managed by Bert Knowles, and its clientele included businessmen, particularly from the Exchange just a few minutes' walk away. Sam's is particularly renowned for its former famous regular, the eminent local painter L. S. Lowry, who knew Bert Knowles from his art school days. Today, we know Lowry as one of the most prolific and distinctive artists of his time in capturing twentieth-century scenes of working-class Manchester and Salford. Such is the pride and esteem of this famous customer that a specially commissioned life-size bronze statue of the great man sat at the bar was installed in 2011. This was the inspiration of chop-house owner Roger Ward, having seen a statue of Ernest Hemingway at a bar in Cuba. Preston-based sculptor Peter Hodgkinson was approached to take on the project. It was no easy task positioning the statue in the bar, which resulted in a crane and window removal! Today, the statue is an iconic attraction for selfies and Sam's is a true city centre attraction offering a distinct Victorian-style interior, good traditional food and distinctive heritage in the heart of the city.

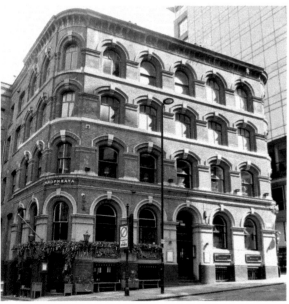

Above and left: Sam's Chop House.

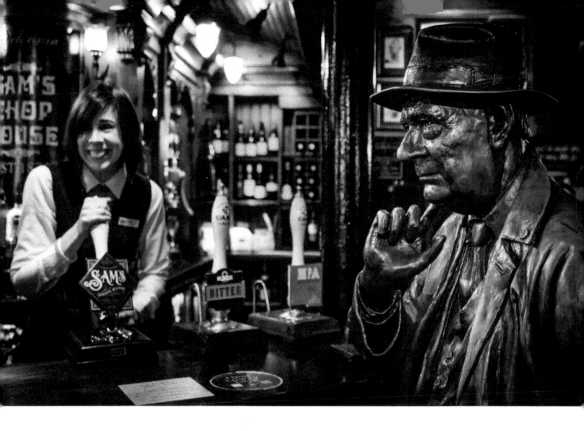

Above: Bronze statue of L. S. Lowry inside Sam's Chop House. (Courtesy to photographer Paul Husbands and Chop House owner Roger Ward)

Right: The 'Lowry Gang', including eighty-nine-year-old photo-journalist Sefton Samuels, Roger Ward, owner of Manchester's Chop Houses, and sculptor Peter Hodgkinson. (Courtesy to photographer Paul Wolfgang Webster and Chop House owner Roger Ward)

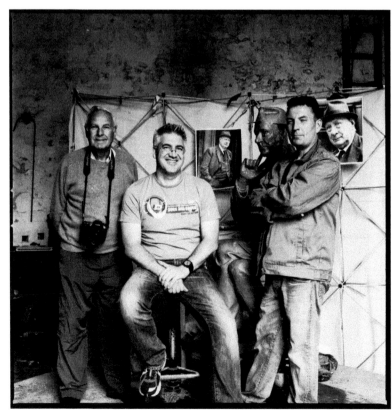

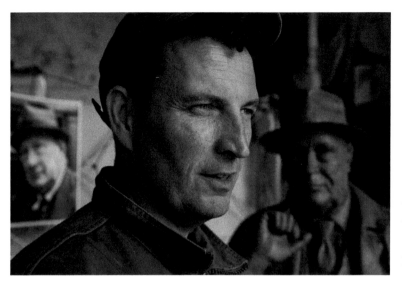

Sculptor Peter Hodgkinson with a clay cast of the L. S. Lowry sculpture. (Courtesy to photographer Paul Wolfgang Webster and Chop House owner Roger Ward)

The Fountain House (formerly Albert Square Chop House), Albert Square

The Fountain House is formerly the Albert Square Chop House, and an initial glance of the building confirms that it looks nothing like a pub or restaurant, still retaining the grandeur of the former Memorial Hall it once was. In the 2000s it was empty for some time until it was opened as a restaurant in November 2012. The ground floor contains the main bar area with a downstairs restaurant on a floor that is just below street level. It has retained traditional Victorian décor that befits its grand exterior, whose architecture, by Thomas Worthington, is seen in other parts of Manchester, such as Minshull Street Court House. Worthington's designs were heavily influenced by his visits to Italy, especially Venetian Renaissance Gothic architecture. Today it is hard to imagine that the Memorial Hall was constructed a decade or so before the nearby town hall and even the formalisation of Albert Square itself. The concept of the hall was agreed in around 1863 and its intention was 'to consider how the memory could be best perpetuated of the 2,000 nonconforming ministers who, on St Bartholomew's Day 1662, resigned their livings in the English Church'.[3] The £10,000 required for the construction was paid for by subscription of notable figures of their day. The lower floors were let out as warehousing and entered via South Street, and the main hall's entrance fronted Albert Square and occupied the upper levels. The cornerstone was laid in June 1864 and opened in January 1866, and Revd William Gaskell, the husband of Victorian novelist Elizabeth Gaskell, conducted the official opening. Revd Gaskell was the minister at Cross Street Chapel for several decades during the nineteenth century, and both he and the chapel were vitally prominent in Manchester's religious life during this time. The Memorial Hall became a major venue for the numerous civic, political, religious and cultural clubs and societies that existed at the time. From Liberal advocates to a choir run by Sir Charles Hallé, it was a key venue in the city's life. This continued into the twentieth century, where first it became a pre-war concert hall, and in 1949 Manchester's 'Press Club'

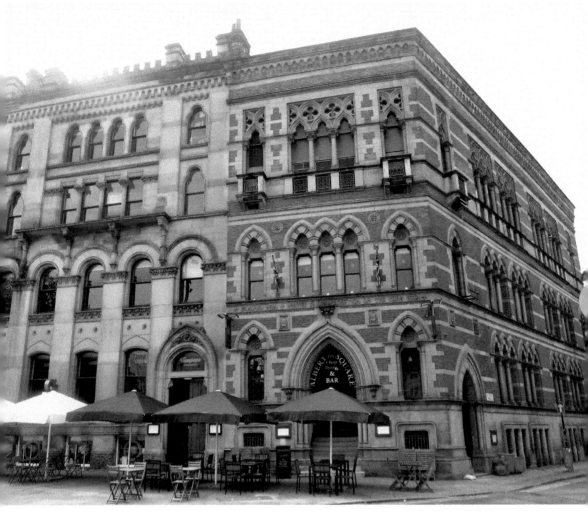

The Fountain House.

found new premises in the hall, opened by notable newspaper editor of the time Lord Kemsley. More recently, the lower ground floor has been a warehouse, the Kardomah Café, Consorts nightclub and a pub-theatre. The upper ground floor was taken by the iconic Albert Square public house. By 2012 it became part of the Chop House group, but in 2021 was taken over by the London-based Metropolitan Pub Company.

Town Hall Tavern, Tib Lane

Despite being close to the current town hall, the Town Hall Tavern was named after its former role as a townhouse before becoming a pub in the early nineteenth century when the town hall was located in King Street about five minutes' walk away. Tib Lane can be seen in maps as far back as the 1750s and during the eighteen and nineteenth centuries, Tib Lane was occupied by smart Georgian housing and businesses, including tailors, the local excise and Sherriff's office. Specifically, in 1800 Thomas Haydock, a language teacher, and Margaret Temple and a school for young ladies were located at No. 16, John Travis hairdressers at No. 18, and William Burton, a cotton dealer, at No. 19. The pub

itself dates from the 1820s and was located at No. 16. The first known entry in the local press that refers to the pub was in the *Manchester Mercury* in 1823, where an inquest was held at the pub concerning the discovery of a baby's body found in a nearby river.[4] Another inquest in 1826 was held in connection with the murder of a woman that had been visiting nearby pubs around Manchester and had been found beaten.[5] The Town Hall Benefit Building Society was established at the pub in 1852, a service we see in many pubs at the time in the absence of formalised institutions that met this kind of need.

Into the twentieth century, the Town Hall Tavern was formerly under the management of Worthington & Co. Brewery, who subsequently merged with Bass, Ratcliff & Gretton in 1927. Worthington ceased brewing as a separate brewery in 1967. It was retained by Bass Brewery until the 1980s and has had several name changes that have included Copper Butts (when it was run by Bass) and Flairs before returning to its more traditional name of Town Hall Tavern. Like a few other pubs in Manchester, the Town Hall Tavern is also believed to be the home of a ghost, this time an Edwardian gentleman in a frock coat, and it is believed that if you get the opportunity to look at him directly he disappears and you are likely to come into some money! Today, the pub is a popular bar and restaurant, whose architecture has remained sympathetic to its heritage.

Below left: Town Hall Tavern.

Below right: Town Hall Tavern with the Town Hall in the background.

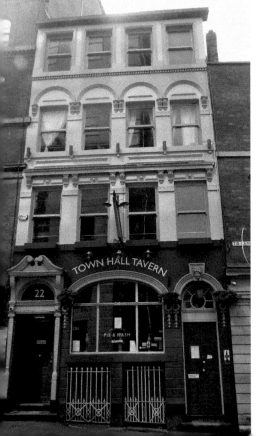
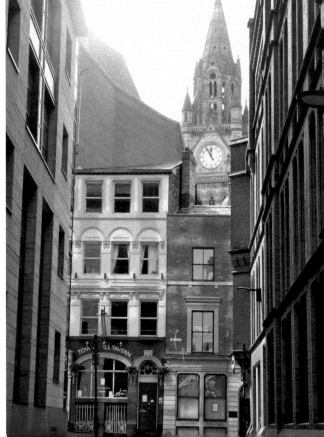

The Sir Ralph Abercromby, Bootle Street

One of Manchester's oldest public houses, the Sir Ralph Abercromby, is tucked away in a back street that is easily missed between Albert Square and Deansgate. The pub was named after a Lieutenant General in the British Army involved in the Napoleonic wars, who, following a distinguished military career, became a Scottish Member of Parliament. Originating from the end of the eighteenth century the pub was in existence at the time of the Peterloo Massacre in August 1819, and its proximity to events that day meant it had a pivotal role on the front line, and it is believed that it was turned into a refuge for some of the victims that were taken to the pub, and indeed an interior mural of the massacre displays events of that fateful day.

In recent times this former Chester's Brewery pub faced financial difficulties and in 2011 reopened after six months of closure, saved by the former landlord of the Circus Tavern on Portland Street, George Archondo, who came out of retirement to reinvigorate the ailing establishment. In 2017 the pub was under threat again, along with other culturally important buildings such as the nearby Manchester's Reform synagogue, and once more saved, thanks to locals and CAMRA (the Campaign for Real Ale) opposing a proposal to redevelop the area by former Manchester United players Gary Neville and Ryan Giggs. Neville was reported as saying 'There's no doubt we underestimated, not the architectural importance of the pub, but the actual social

Sir Ralph Ambercromby, which recently survived potential demolition.

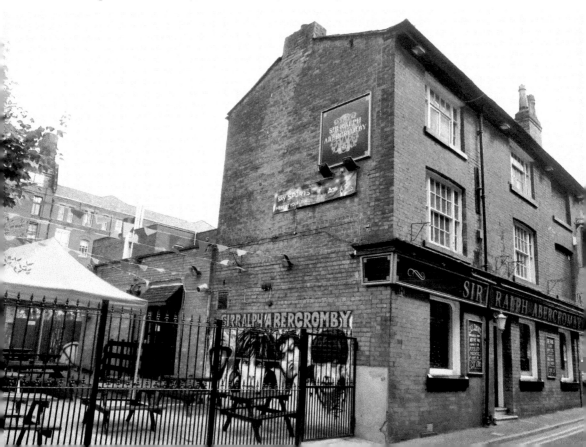

community importance of the pub'.[6] The fact was that both these issues are vital to our heritage, which has become a battle in central Manchester, whose rapid modern expansion endangers the city's rich cultural heritage.

Old Nag's Head, Jackson's Row

The Old Nag's Head, like the Sir Ralph Abercromby a couple of minutes away, is another old establishment that we can trace from the end of the eighteenth century, though the original pub was rebuilt in 1880. In 1788 we see it first recorded in a local trade directory, occupied by the sawyer John Brown, who clearly engaged in a second occupation besides being a publican. John Brown was at the pub until the late 1790s, since by 1797 Richard Hunt occupied the premises. We gain glimpses of the interior through a sales advertisement in 1830, and its particulars gave us an insight into the interior, containing a parlour and a newsroom.[7] Newsrooms were an important feature of pubs which allowed access to newspapers and facilitated 'readings' so the illiterate could keep abreast of current affairs. One of its former publicans, William Fulford, went on to form a local brewery, Gill & Fulford, at the Horseshoe Brewery in Salford around 1877.

Despite its heritage, it is the more modern features of the pub that make the Old Nag's Head stand out. The inside could be described as a shrine of pictures of characters in local life. Outside contains a range of artwork, including murals dedicated to former Manchester United star George Best and local Hacienda and Factory Records guru

Below left: Old Nag's Head.

Below right: Mural on the chimney of Old Nag's Head depicting former MUFC player George Best.

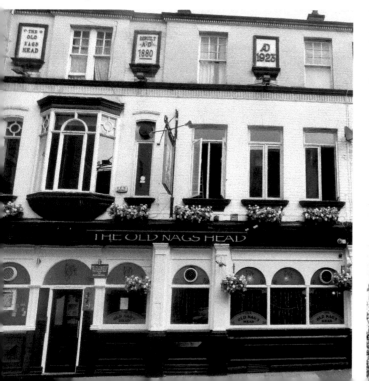

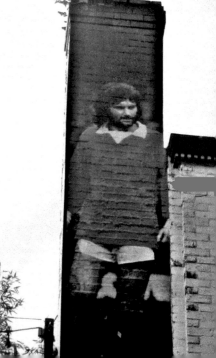

Tony Wilson. A beer garden is surrounded by other characters such as actress Maxine Peake, suffragette Emmeline Pankhurst, and musical legends such as Noel Gallagher, the Stone Roses, and Morrissey, to name just a few. A further piece of artwork includes a 'last supper' depiction of political and cultural figures, such as the region's mayor Andy Burnham and film director Mike Leigh. The restoration of the beer garden is the achievement of Warrington artist Stephen Lynn.

The Rising Sun, Queen Street

The Rising Sun is oddly compressed between modern office blocks with entrances in both Queen Street and Lloyd Street at the rear, in the area between Albert Square and Deansgate. Queen Street was certainly in existence by 1750 and the Rising Sun is certainly old, but how old is difficult to establish. For example, there was a Sun public house at No. 34 Queen Street in 1794, occupied by Thomas Lees, who was still at the premises in 1797. By 1800 there was still a Sun pub managed by Charles Turner at No. 34. Charles died in 1806 and appeared to have been taken quite young according to the newspaper article, which also mentioned his role in the Royal Manchester and Salford Volunteers where he was a serjeant.[8] The most certain record we have is in 1818 where a Rising Sun is recorded at No. 28 Queen Street, occupied by Samuel

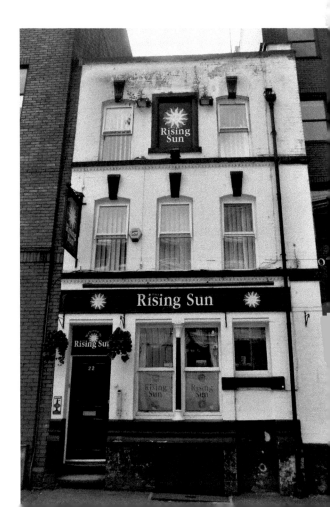

Front of Rising Sun.

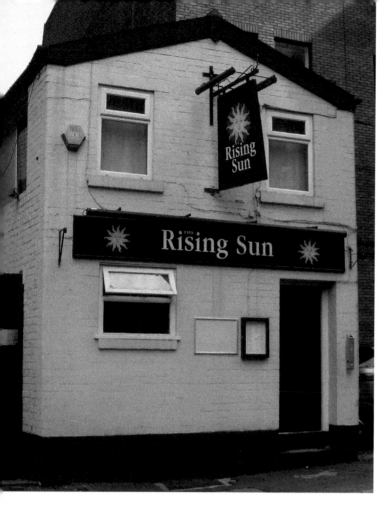

Rear of Rising Sun.

Street. In 1836, under the management of James Maire, Mary Wilkinson, a servant employed at the pub was convicted of stealing two sovereigns and further investigation revealed that she had been stealing from the pub for some time.[9] By the 1850s Manchester had become more densely populated and the pub had been surrounded by nineteenth-century urbanisation. This is reflected in the local press in 1854 where an auction at the pub described it as 'the old-established public house, known as the Rising Sun situate in Queen's Street Deansgate, Manchester being in the midst of a densely populated district', containing a bar, bar parlour, sitting, club and taprooms.[10] A former Wilsons Brewery pub in the 1970s, it had a spell as a Chef and Brewer in the 1980s and 1990s, but today is back to being a traditional pub.

The Moon Under Water, Deansgate

The Moon Under Water once held the status as the largest pub in the United Kingdom and is still one of the largest pubs in the Wetherspoons chain. Its size reflects its former use as a 700-seater cinema, which was known as the Deansgate Picture House, the ABC and the Cannon over the years. Opening in 1914, it went through renovations in 1930 following designs of G. Allen Fortesque and remained a cinema until 1985.

Thankfully, many of the original features can still be seen in the pub, including cornice and wall decoration, railings, and an original projector from its cinema days that is a distinctive feature on the pub's upper floor. It also houses an ornate stained-glass window that spans two floors and whose image is reflective of its name.

Its unusual name is attributed to a work from renowned author George Orwell, whose 1946 work referred to a 'perfect pub' of the same name. The literary offering is framed and available for customers to read at the entrance to the pub. The Moon Under Water has been managed by Wetherspoons since 1995, for some time being regarded as their flagship pub, and it can house around 1,000 people at any one time in its three bars.

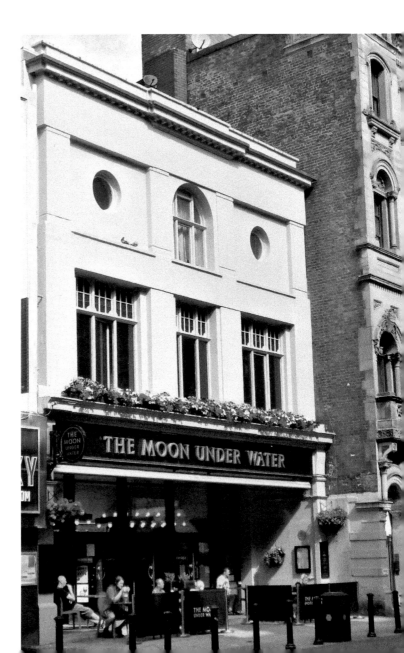

The Moon Under Water, revealing its former role as a cinema.

The Lost Dene, Deansgate

The Lost Dene pub is on the ground floor of Grampian House, which contains offices on the additional four floors. Like the Moon Under Water, it is not a pub architecturally constructed in the traditional sense. During the mid-nineteenth century the site on which the Lost Dene is now located contained two other pubs, namely a Bull's Head and Red Lion. By the late 1800s, the site was occupied by the King's Head Hotel and a workshop for Henshaw's Institute for the Blind.[11] The current building dates from around the 1940s, and images of the time indicate that in January 1940 the ground floor was used as an air-raid shelter and during the 1950s

The Lost Dene with John Rylands Library in the background.

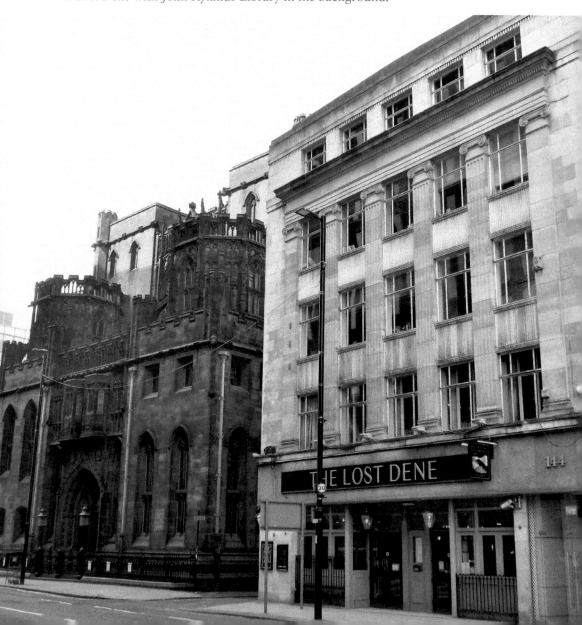

was part of Manchester city's architect department. Subsequently, the ground floor of Grampian House was occupied by a furniture store, first known as Woodhouses, followed by Smarts during the 1950s. As a recent public house, it was initially named the Hog's Head and became the Lost Dene in 2011 and it is believed its name reflects a lost river that ran nearby. For a short period over the summer of 2016, it was renamed the Three Lions in support of the England football team that took part in the European finals.

Sawyer's Arms, Deansgate/Bridge Street

The Sawyer's Arms is one of Manchester's oldest public houses, and some suggest that it first gained its licence in the 1730s. While this is difficult to ascertain precisely, it certainly dates from the eighteenth century. The earliest record of the pub can be found in the Constables Accounts for 1775–1776, which records a coroners' inquest held at the pub.[12] The first known entry in the local press is from the *Manchester Mercury* in November 1778, which reveals the pub was occupied by William Rushworth and where an auction was taking place.[13] He ran the pub until somewhere up to the late 1780s, since by 1788 it was occupied by Thomas Sandiford. The pub was in the news again in 1877, where the *Manchester Evening News* reported that the landlord of the time, George Martin, was charged with permitting drunkenness in the pub. His defence was that he did not realise that two men were drunk, but his unconvincing story led

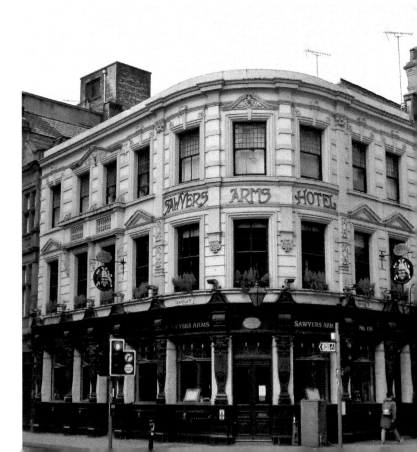

The Sawyer's Arms.

to a fine of 20s, though despite this he did manage to keep his licence.[14] In December 1907 one of the Sawyer's Arms most prominent landlords, John Archdeacon, died suddenly at the age of sixty-three. Archdeacon was well known in the city, having been prominent in the Licensed Victuallers Association, the Freemasons, and former grandmaster of the Buffaloes Grand Lodge.

The Grade II listed building has a distinctive corner plot at the corner of Deansgate and Bridge Street, decorated with stucco on brick and glazed terracotta design, and thankfully subsequent twentieth-century renovations have managed to retain its original features. In the 1960s and 1970s, the Sawyer's Arms was a regular haunt of former Manchester United footballing legend George Best. A former Wilsons Brewery pub, the establishment is currently run by the Nicholson group that manages the Old Wellington in Shambles Square and the Bank in Mosley Street.

The Ape & Apple, John Dalton Street

Located just a couple minutes' walk from Albert Square, the building that houses the Ape & Apple became a pub in 1997. It is currently managed by Joseph Holt's Brewery and had been refurbished in a traditional Victorian style. However, it was not built as a public house and the premises has had a variety of uses in the past. For example, in 1911 there was a dressmakers' shop and iron merchants on the site. In 1954 it was a solicitors and chartered accountants. More recently it was a bank. One feature outside the Ape & Apple pub is a blue plaque in tribute to one of Manchester's most famous scientists, John Dalton, where the street is also named in his memory. He was regarded as the father of modern chemistry and received international acclaim for his scientific achievements that include work on colour-blindness and the hydrological cycle. John Dalton lived in Manchester from 1793 until his death in 1844. For anyone wanting to dabble in stand-up comedy, the pub hosts Manchester's longest-running free comedy club, the Comedy Balloon, which is held each week.

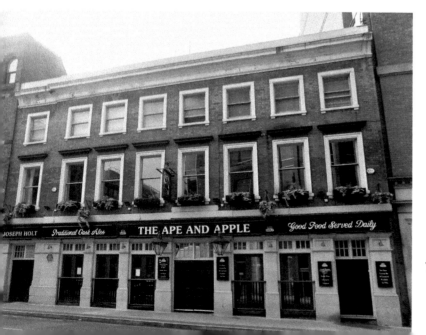

The Ape & Apple.

Mulligans, Southgate

Mulligans, tucked away in a back Street off Deansgate, claims that it is Manchester's oldest Irish establishment and is particularly known for its Guinness. The pub was previously known as the Waggon & Horses from the 1820s up until relatively recently and became Mulligans in the 1990s. The pub comprises of a long lounge with a stage at one end for a fiddle-dee band to perform. In 1824 the Waggon & Horses was occupied by William Pixton and Southgate was then known as Pork Shambles, which by 1828 had become New Shambles Street. We also know at this time that the pub contained an on-site brewhouse since a newspaper article reported that it had been on fire.[15] The pub was also opposite Bridge Street market. The Waggon & Horses was beset with tragedy in the 1880s. In both 1882 and 1885 there were suicides at the premises and both involved shootings. In 1882, Robert Armstrong, manager of the pub, shot himself upstairs, and in 1885 James Hall turned a gun on himself in the smoke room.[16]

The Waggon & Horses was formerly managed by Chesters Brewery, then into the twentieth century came under the tenure of Watneys and Wilsons breweries. Mulligans has always attracted a following of Manchester United and indeed in the 1980s when the likes of Roy Keane and Denis Irwin were United players, they were known to begin post-match celebrations, and the pub retains its loyalty to the 'reds'.

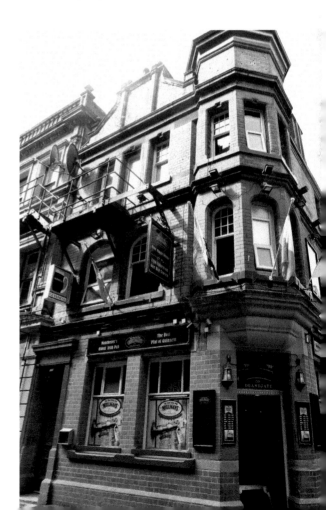

Mulligans Irish Pub.

3

Piccadilly to St Peter's Square

Star & Garter, Fairfield Street

The Star & Garter, dating from 1877 at its current location, was Grade II listed in 1988. It is a distinctive red-brick Gothic-looking building with a steep slate roof and the pub is believed to have started its life around 1803 some 50 yards or so from its current position on Fairfield Street. It was relocated in consequence of the development of London Road (now Piccadilly) railway station, and its connection to Oxford Road station at the other side of the city in 1849. The Star & Garter was purchased by Thomas Chesters in 1872 and remained with Chesters Brewery after Thomas' death, but subsequently became a Threlfalls Chesters Brewery in 1961 following their merger, and subsequently became part of Whitbreads Brewery in 1967 after a further takeover of Chesters.

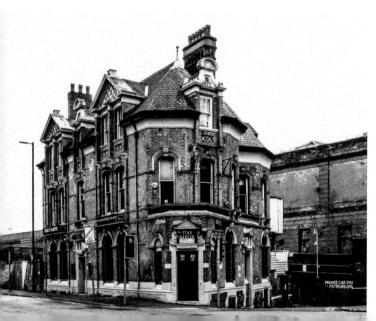

Star & Garter. (Courtesy of Phil King)

In modern times the pub has developed a reputation as a popular music and indie venue hosting a variety of rock bands, including the popular group Status Quo. Its famous monthly 'Morrissey Smiths Disco' nights have attracted fans from around the world. In 2014, its long-running indie night 'Smile' celebrated its twenty-first anniversary. The Star & Garter's future has remained in the balance and regulars and fans thought that the pub was soon to close, possibly forever. The pub first found itself in jeopardy when nearby Mayfield railway station finally closed in 1986 and Chester's Brewery put the pub up for sale, but it managed to survive. In 2019 the future of the pub became more certain when a new ten-year lease was agreed and the intention is for the pub to form part of the regeneration of the area at the back of Piccadilly station.

The Bull's Head, London Road/Fairfield Street

It is believed that a pub has been on the site of the Bull's Head from around 1786, though first known entries of a pub's existence can be found in the local 1794 trade directory, which records that Matthew Sumner occupied a Bull's Head at No. 87 Bank Top, which is the original name for the highway that is the modern London Road, adjoining the corner with Granby Row. Mr Sumner was at the pub for a while as

Bull's Head.

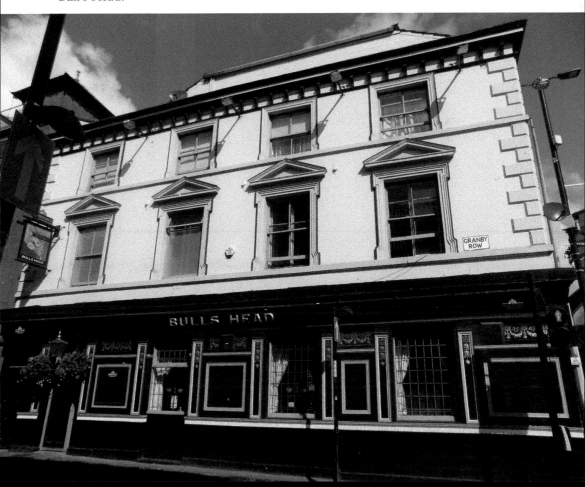

he was still there in 1800. Other prominent occupiers included Robert Meadowcroft from around 1817 to 1821, and the Lowcocks in the 1830s to the 1850s, first managed by Samuel Lowcock, followed by wife Maria who took over around 1849. The Bull's Head, like many pubs of the time, held an important community function, since it was the location for the County Building Society, which was operating in the 1830s, and it was also a popular venue for meetings such as political gatherings, such as electors of the Oxford Ward district, and trade groups such as the Operatives Association.

Like the Star & Garter, the Bull's Head has managed to survive the continued expansion of the former London Road (Piccadilly) station and currently holds a prime position in attracting railway users for a drink or overnight stay. It is traditional Victorian elegance is popular with both local city workers and tourists alike. A former Wilsons Brewery pub around the 1970s and Burtonwood Brewery during the 1990s, the Bull's Head continues to be run by Marston's Brewery.

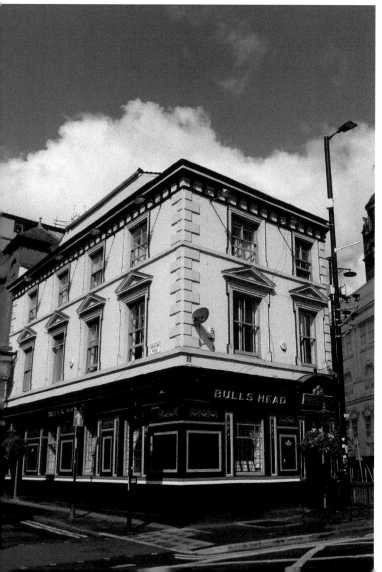

Bull's Head looking towards Granby Row.

OYO Mother Macs, Back Piccadilly

An old-fashioned back street boozer, Mother Macs has always had a dedicated following. Originally known as the Wellington and dating back to the early nineteenth century, the first known entries from trade directories indicate its existence from the 1810s. It was known as the Wellington up to around 1970 when it was renamed Mother Macs after a former landlady, Mrs McClellan, who, despite being a teetotaller, had occupied the pub for well over thirty years. She had a strong association with the Grenadier Guards, who had a prominent role in her funeral procession, which proved to be a major event in central Manchester. A plaque outside the pub is dedicated to her memory.

Mother Macs achieved unwelcome notoriety in June 1976 when the pub suffered a dreadful fate. The twenty-nine-year-old pub manager, Arthur Bradbury, was given notice to leave the establishment and he took this news particularly badly and made the fateful decision to murder those around him including his thirty-four-year-old wife Maureen, his six-year-old daughter Alison and his stepsons James and Andrew, aged eleven and thirteen, respectively. The cleaner inadvertently walked in on his actions and he killed her too, then set the place alight in part to cover up evidence. Finally, he ended his own life, resulting in five murders and his suicide. Consequently, the pub has gained a reputation for being haunted.

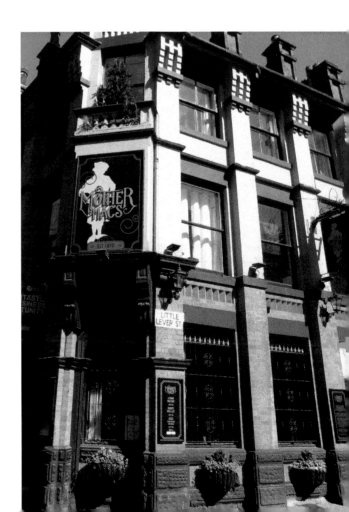

OYO Mother Macs.

The Shakespeare, Fountain Street

There has been a Shakespeare public house in Fountain Street from around the latter part of the 1700s and the first entry in the local trade directory reveals that a Shakespeare Tavern was occupied by Widow Biers in 1788. There are two complications in tracing the pub's history. First, there are several variations to the spelling of Shakespeare. Second, the property numbers changed throughout the nineteenth century. Fountain Street began to be developed from around 1772 when the streets around the upper end of Market Street toward Piccadilly and Oldham Street were being turned into established highways and it was so named because of the underground spring that resided there.

The pub itself looks Tudor and is a bit of a mystery concerning its heritage. It is believed that all or part of the exterior was taken from another pub located in Chester, the Shambles Inn, which dated from around the 1650s and was being demolished. However, evidencing these claims is difficult and there is no evidence of a Shambles Inn having ever been in Chester. A report in the *Manchester Guardian* in February 1927,

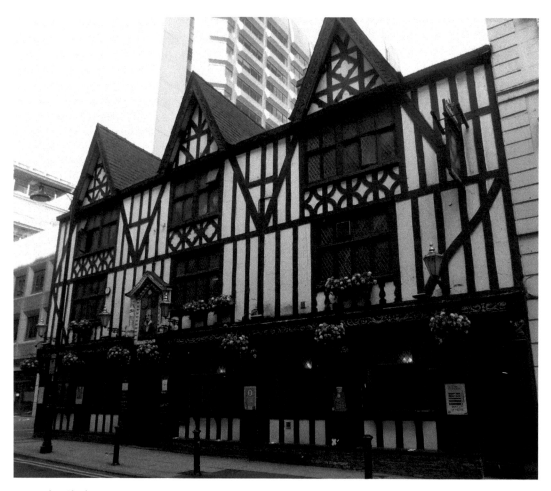

The Shakespeare.

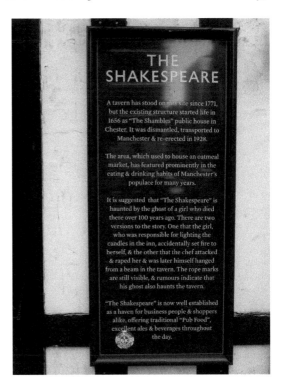

Right: Panel on the side of the Shakespeare depicting its past.

Below: Carvings on the front of the Shakespeare.

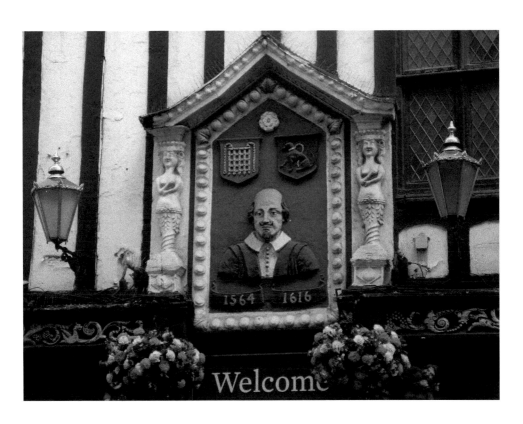

which commented on a fire that had beset the pub, indicated that a new frontage had been installed at the Shakespeare in 1924 but no clue as to its origins. It also described the pub as a 'curiosity', so the mystery continues. [1]

The Shakespeare was struck with tragedy in 1859 when the wife of the landlord John Foster was a passenger on the Royal Charter vessel that was wrecked off the coast of Ireland. [2] The pub is believed to be haunted by the ghost of a young girl and there are two versions to her story. The first is that she accidentally set herself alight, and secondly it was alleged she was raped and murdered by the chef, who went on to hang himself in the pub. The rope marks are allegedly still visible on a ceiling beam. The ghost is reported to stand at top of the stairs in the pub, appearing to be on fire. The Shakespeare was managed by Chesters Brewery pub in the late nineteenth century, but it was more recently owned by Wilsons Brewery, who acquired it through a takeover of Kay and Whittaker's Brewery in 1904 until the 1970s.

The Bank, Mosley Street

This Grade II listed public house forms part of the original Portico Library, where it occupies the former ground floor newsroom. The open-plan interior incorporates many of the building's original features, retaining its former grandeur. The building dates from 1806 and was built in a neoclassical style, designed by Thomas Harrison, an architect who had developed a reputation for producing great classical buildings in a Greek Revival style. The Portico was one of the first of its kind in the country, with an impressively ornate ceiling dome and four external ionic pillars and frieze. The Portico Library was an independent subscription reading room and library, designed for leading Mancunian merchants and gentlemen who had witnessed the opening of the Liverpool Athenaeum and wished to see a similar facility in Manchester. Two businessmen, in particular, Robert Robinson and Michael Ward, embarked upon its creation, paid for by subscriptions at a cost of nearly £7,000. It comprised of a newsroom, which during the early nineteenth century was one of the only places where London newspapers could be accessed, a library and a reading room. Its membership was a 'who's who' of Manchester society, including notable scientist John Dalton, politicians Richard Cobden and John Bright, and police force founder Sir Robert Peel. For many years, its chairman was Revd William Gaskell, minister at Cross Street Chapel and husband of novelist Elizabeth Gaskell. At the outset, its membership was confined to affluent men, until after 1870 when women who qualified under the Married Women's Property Act could become members, and this allowed membership for notable women like Elizabeth Gaskell. However, before she could formally join the library, it is believed that her husband, William, borrowed books for her. Today, her novels are some of the most noted works in their collections.

Into the twentieth century, the building faced financial difficulties and the ground floor was let out to institutions such as the Bank of Athens, who leased the premises in 1921. In the 1990s the ground floor became a public house and, as part of the Firkin group, became the Forgery & Firkin. More recently it formed part of the Nicholson group that manages the Old Wellington and Sawyer's Arms and was renamed the Bank public house.

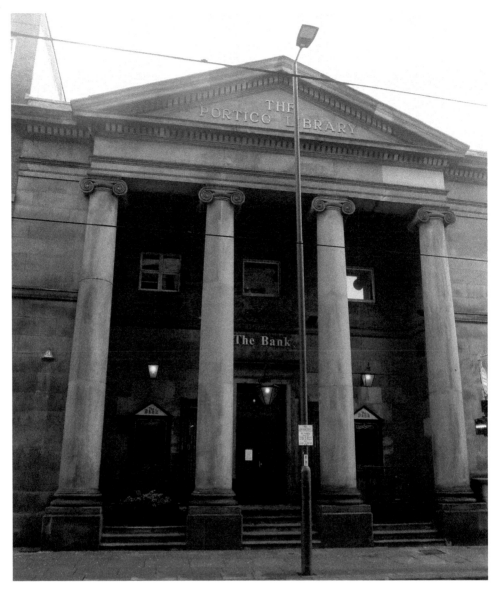

The Bank, originally part of the Portico Library.

Seven Oaks, Nicholas Street

The Seven Oaks is an unusual white glazed brick building located at the edge of Manchester's famous Chinatown and side of Manchester Art Gallery and Athenaeum, and the Portico Library, where during the nineteenth century the area was one of Manchester's more affluent areas and dominated by the merchant middle class. The Seven Oaks dates from around the 1820s and was originally occupied by James Jones. The establishment bore witness to some particularly interesting events during the nineteenth century. For example, in May 1829 rioters were rampaging around central Manchester,

Seven Oaks.

and a large body of them proceeded to the Seven Oaks to demand money, which was duly received. They split their loot between them and went on to other pubs in the area demanding the same.[3] In April 1838 the pub was at the centre of another incident. This time police officers were in the pub surveilling three well-known thieves in the area who were robbing the wine cellar from the Royal Institution (currently the Manchester Art Gallery) across the road, which they eventually apprehended.[4] The Seven Oaks was for sale in 1842 and the advertisement gives us glimpses into its role in society, where its proximity to commercial outlets, concert rooms and theatres was a key selling point and made claim to having one of the best bars in Manchester.[5] In 1853 the landlord, George Rusling, was charged with assaulting a commercial traveller who was being ejected from the pub, which led to an altercation for which George Rusling gave the man a beating.[6]

Later the same year, George's wife died by accidentally setting fire to her clothing in the kitchen of the pub and was fatally injured.[7]

The outline of an oak tree growing across the front of the building is a modern addition since pictures of the pub in the 1970s are minus the tree design. The Seven Oaks has a membership scheme for late-night drinkers and is a popular venue to watch sport, showing up to seven different sporting events from across the globe at any given time. The pub is well known among the bar workers of Manchester it allows them visit the pub from midnight until eight in the morning so they can enjoy a post-work drink.

The Grey Horse Inn, Portland Street

The Grey Horse Inn and Circus Tavern share a similar heritage and were originally part of a row of eighteenth-century cottages that are rare examples of original city centre industrial houses that have survived into modern times. Both pubs are reflective of their former use and are two of the smallest pubs seen anywhere. If indeed the Circus Tavern is, as it claims, the smallest bar, the Grey Horse Inn, just three doors away, must be in

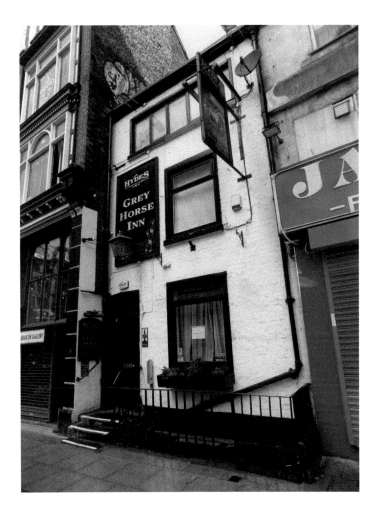

The Grey Horse Inn.

the same vein as one of the former eighteenth-century cottages that were converted into beerhouses in the centre of Portland Street. Beerhouses were a type of establishment post-1830 that just sold beer and one could easily get a beerhouse licence. During the nineteenth century they were a source of social order concern. Many closed but some that survived often turned into full public houses. The site of the Grey Horse Inn was a private house up to the early 1840s, at this time inhabited by James Knight who owned a land and building agent business in the city. However, by 1847 it had become a beerhouse, occupied by George Langton. Around a century later it had gained its full public house licence and the 1954 local directory records it as the Grey Horse Inn occupied by William Dowling. The establishment has been managed for many years by the local brewer, Hyde's Brewery, who acquired the pub in 1929. Its façade remains relatively unchanged, retaining an old cottage feel and traditional pub experience.

The Circus Tavern, Portland Street
The Circus Tavern resides just three doors away from the Grey Horse Inn, and which claims to be the smallest bar in the city and possibly even Europe, with a bar at most a metre long. The Circus is again a former eighteenth-century cottage that was converted into a beerhouse, and again, like the Grey Horse Inn, eventually obtained a full public house licence. In 1841 we know that the premises were inhabited by William

The Grey Horse Inn, Circus Tavern and Old Monkey on Portland Street.

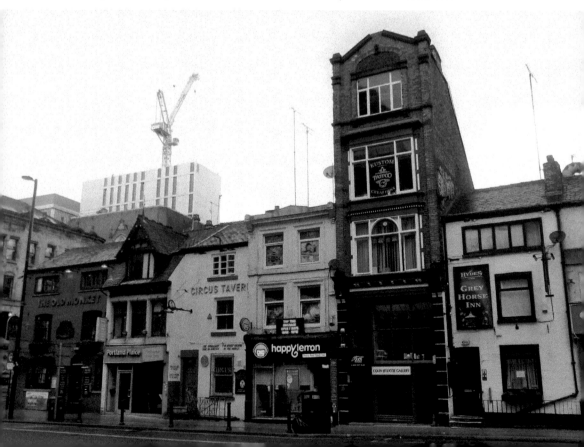

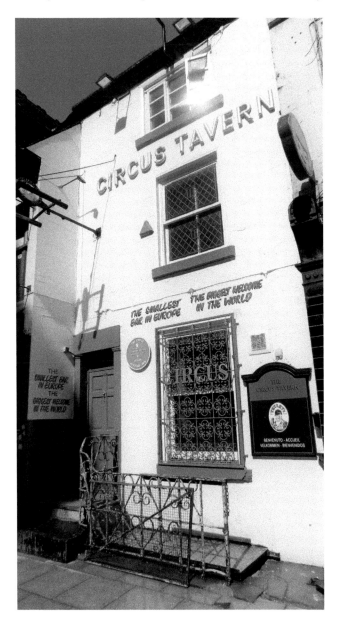

The Circus Tavern.

Isherwood, an awl blade maker, but by 1850 has become a beerhouse and at this time occupied by Henry Clarkson. The Circus Tavern is a Tetleys Brewery Heritage Pub, and the landlord describes the establishment as 'the smallest bar in Europe, but the biggest welcome in the world', a slogan that is proudly painted on the exterior. The unusual name for the Circus indeed reflects that a circus used to exist across the road from the pub in Portland Street during the nineteenth century. During the 1970s it became a haunt of former footballer George Best and other Manchester United players. Today, the Circus offers a traditional pint and is a very popular venue in the city centre.

The Old Monkey, Portland Street

The Old Monkey, located at the corner of Portland Street and Princess Street, is managed by Joseph Holt's Brewery. Opened in 1993, it is one of the few new-build public houses in the city centre. The site, however, is no stranger to a hostelry and once contained a beerhouse on the site from the 1830s until the 1920s, which became known as the Queen's Arms. A confectioners' shop that existed next door from the 1880s appears to have extended into what was the beerhouse by the 1920s and was still in existence well into the 1950s. By 1973 we know that Portland Street bookshop was located on the corner of Portland Street and Princess Street and by 1984 it had become Ladbrokes bookmakers. By 1993 the new Old Moneky pub had been built and was of Joseph Holt's flagship pubs. The Old Monkey is home to the Trapdoor Comedy Club, which runs monthly comedy nights with comedians such as Gary Delaney, who have gone on to appear in television programmes such as *Never Mind the Buzzcocks* and *Mock the Week*.

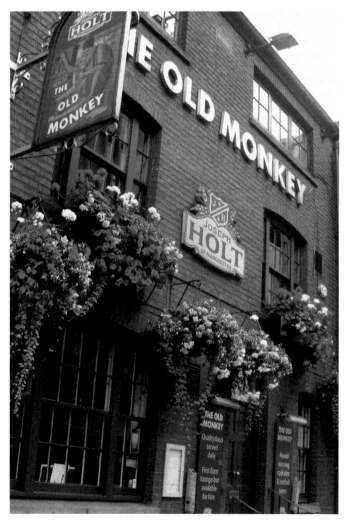

The modern Old Monkey.

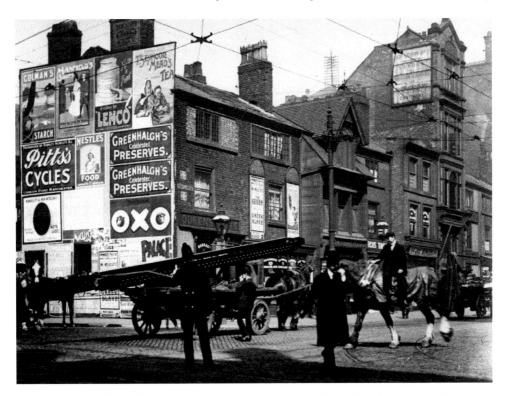

The site of the Old Monkey in 1904 on the corner of Portland Street and Princess Street, with the original Queen's Arms pub in the background. (Courtesy of Manchester Archives and Local Studies Library)

The Vine Inn, Kennedy Street

The following two pubs adjoin one another in a narrow street behind St Peter's Square. Both were Grade II listed in 1974 and, like the Waterhouse that forms part of the same block of buildings, are former townhouses. The buildings appeared on maps dating from the 1790s. Spread over three floors and extending into a larger space next door to its original cottage, the Vine Inn is distinctive with its traditional green tile exterior. You will notice the row of windows at the top of the Vine Inn, which reveals the building's former use concerning textile production such as weaving. In 1794 the houses that made up the Vine Inn were occupied by a warehouseman and a bookkeeper. By 1797 the cottages were occupied by Catherine Charlston, a finisher of fustians, and John Partington, a dyer and printer. Into the 1830s, the occupants of the two houses included James Colbeck, a dresser of silk muslin. By 1850 John Jones ran a tailor's outlet, and George Lucas was an engraver. The Lucas family appeared to be around for some time since George was still around in the 1860s and by 1863 a Thomas Lucas was recorded as an ironmonger, with Barnes & Ramsbotham calico printers and Lord Speight candlewick maker located next door. In 1877 several businesses were located there including cloth merchants, solicitors and auctioneers. By the 1890s the cottages had become a beerhouse and by 1906 it was recorded as the Vine Inn. The Vine was

known to be a haunt of Manchester United players, and the pub is famous for being home to over a hundred different types of whiskeys. Pictures taken of the pub from around 1970 show a sign for Magnet Ales outside and by 1994 it belonged to John Smiths Brewery. Today it is a free house.

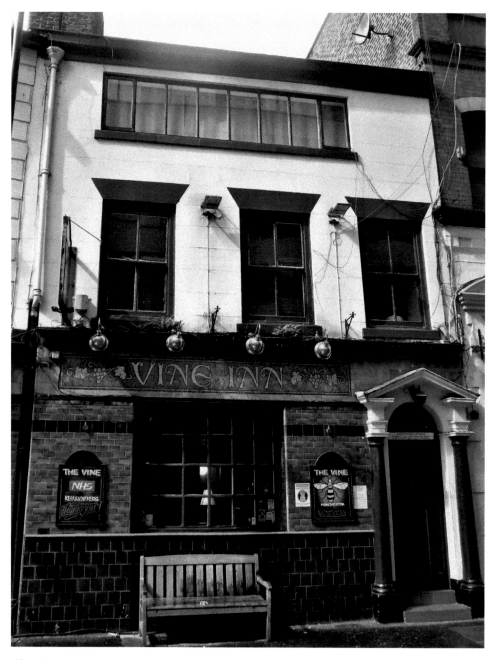

The Vine Inn.

The City Arms, Kennedy Street

Like the Vine, the City Arms is made up of two former townhouses and by the late 1880s it had become a public house. It is joined to the Waterhouse pub at the side and rear and looks quite different externally to that of its Vine Inn neighbour. We know that in 1794, John and James Rothwell, nankeen and calico manufacturers, occupied

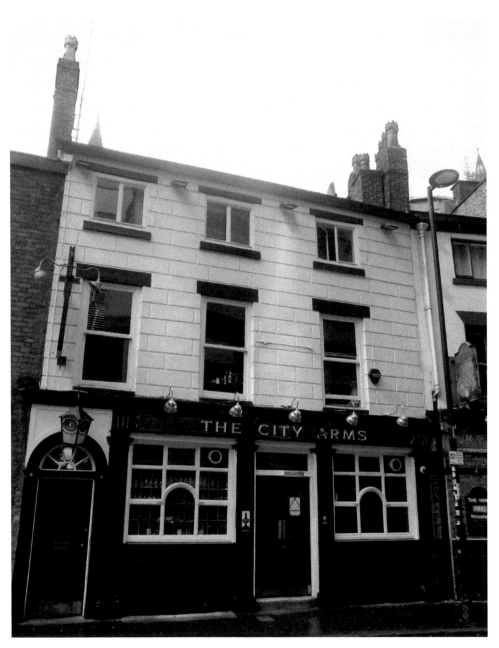

The City Arms.

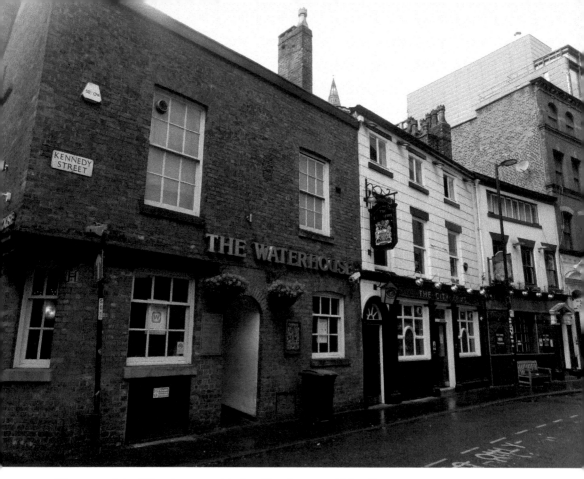

The rear of the Waterhouse, with the City Arms and Vine Inn.

one of the cottages that make up the pub. The cottages became a hostelry during the early 1830s since we see Sarah Simister running a beerhouse. The City Arms is known to have traded with the Mayfield Brewery in nearby Ardwick in the 1870s and 1880s.[8] Into the twentieth century, it traded with the Empress Brewery near Old Trafford, which was subsequently taken over by Walker Cain Ltd, who managed the pub until the 1970s. This was followed by a stint with Tetleys Brewery until around 2015, when the pub was linked to local Lancashire brewer Moorhouses. More recently, like the Vine Inn, the City Arms has become a free house.

The Waterhouse, Princess Street

This Wetherspoon's pub is made up of three eighteenth-century townhouses, of which part was once thought to be an orphanage. Part of the premises was certainly a solicitor's office and a bookcase still containing publications from its time in the legal profession remains. The original cottages that form the current pub are visible on maps of 1794, and trade directories through the decades reveal that they accommodated professional businesses other than solicitors, including accountants, property and surveyor services, and private tutoring. The pub itself certainly

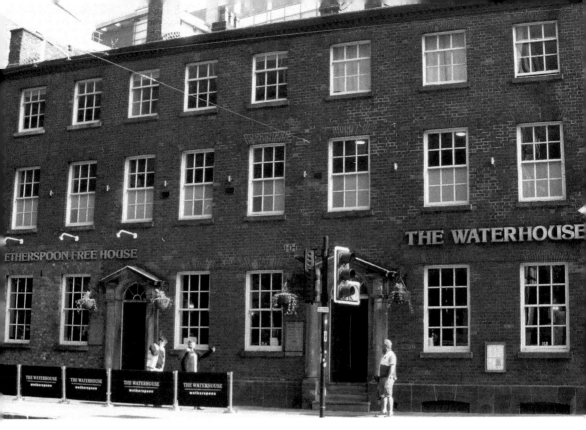

The Waterhouse.

makes the most of the building past, and some original Georgian stone stairs are covered over with glass, which provides a fascinating focal point in the bar. The pub is named after Alfred Waterhouse, who designed Manchester Town Hall, which resides just across the road and the pub's interior features a range of images and other memorabilia that connect to both the vicinity's heritage and the buildings Alfred Waterhouse designed. Waterhouse designed several buildings apart from the town hall, including Manchester Assizes, Strangeways prison, and Manchester University's main 'Owens' building. Manchester Town Hall is the epitome of Victorian architecture and a jewel in the centre of the city, which reflects so much of Manchester's industrious past such as mosaic floors that incorporate cotton flowers and bees that reflect local industrious workers. The 280-foot-high clock tower houses twenty-three bells, including 'Big Abel', named after local statesman Abel Heywood, who opened the building. The Waterhouse still retains a feel of the Georgian houses that it once was.

In and Around Manchester's Gay Village

A small corner of Manchester city centre between Portland Street, Princess Street and Whitworth Street is the area known as the Gay Village, a vibrant corner of Manchester that has several pubs that have a distinctive heritage. The area has been the home of the Manchester annual gay pride for around thirty years.

Churchills, Chorlton Street

Churchills, a Grade II listed establishment, is located on the edge of Manchester's gay village, which was previously known as the Mechanic's Arms. The pub has existed on the site since at least 1850, but it could be even older since there was a Mechanic's Arms on Chorlton Street since 1834, first at No. 29, then at No. 33 in 1841, demonstrating the difficulty tracing buildings with changing door numbers over time. In the mid-1870s William Darnward of the then Mechanic's Arms occupied the premises and the Darnward family continued to occupy the pub until around 1895 when it was taken by Frederick Burgess. In 1911 the pub then passed to a Mrs Annie Sheerin, and just before the Second World War the venue passed to James Taylor. Like many establishments originating from the eighteenth and nineteenth centuries, the pub is believed to have brewed its beer with its own on-site brewery. John Trotter, who was at the pub at the turn of the twentieth century, undertook a major refurbishment, and the pub remained the Mechanic's Arms until at least the 1970s. It is one of the longest-running gay pubs in the village. In October 2020 it was taken by the Bar Pop group, managed by John Hamilton and Antonio Roman, who also manages the nearby Bar Pop venue.

Churchills.

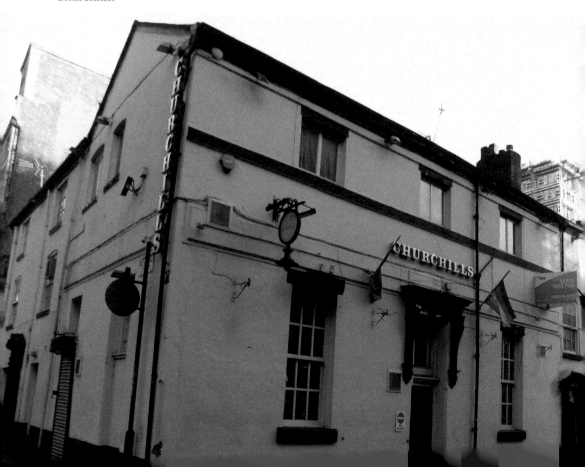

The Rembrandt, Sackville Street

The Rembrandt, affectionately known as the Rem, exists in the heart of the gay village on the corner of Sackville Street and Canal Street at the side of the Rochdale canal, and is one of Manchester's oldest gay bars. It was originally the Ogden Arms, and the first record of the pub's existence appears in the *Manchester Mercury* at the end of 1829 when the landlord Thomas Booth married Susannah Roe.[9] The following year, in 1830 the *Manchester Mercury* reported that Thomas Booth helped to save a child from drowning in the nearby canal.[10] Later the same year he was in the news again, this time for insolvency, and this meant that he left the pub and Daniel Mercer became the landlord.[11] Being at the side of the canal presented some unfortunate situations for the pub and often individuals drowned in the canal either by falling in or being pushed and the Ogden Arms was the place where victims were taken. For example, Edward Berwick was found in the canal near the pub after a plunging sound was heard from the pub, but unfortunately he did not survive and some thought he had been pushed into the water. Similarly, a couple of years later a Mr Caldecott suffered the same fate when he accidentally drowned and his body was taken to the Ogden Arms ahead of his inquest.[12]

The Ogden Arms became the Rembrandt around 1962. The pub became central to the gay scene, though this was at a time when homosexuality was still illegal, and the pub was constantly raided by the police. There are rumours that moors murderer

The Rembrandt.

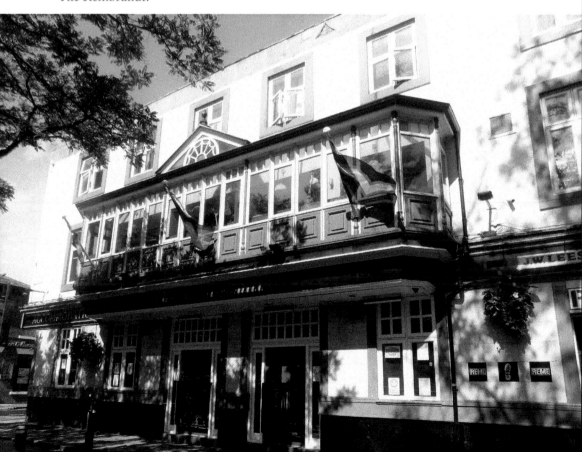

Ian Brady used to visit the Rembrandt, and some have gone as far to suggest that he may have become acquainted with one of his victims, Edward Evans, at the pub but as a verbal story it is difficult to verify.[13] The Rembrandt has remained at the heart of the annual gay pride since it began around thirty years ago and what began as a bring-and-buy sale outside the pub is now one of the biggest LGBT festivals in Europe. The Rembrandt has been under the management of J. W. Lees Brewery since the 1970s.

The Goose, Bloom Street

The Goose, in the centre of the gay village, dates back to the early 1820s when it was originally known as the Ram's Head & Fleece, but around 1850 it became known as just the Fleece. One of the earliest entries of the pub was in the local trade directory for 1824 where we know that Edward Staley occupied the pub. He was still there in 1828 but by 1834 William Read has taken over. One of the longest occupations by a landlord was James Berry, who was at the pub from around 1850 to 1873, and it appears that the name change to the Fleece coincided with the arrival of James. In 1873 the licence was transferred to Sarah Kilner. It was still the Fleece into the 1950s,

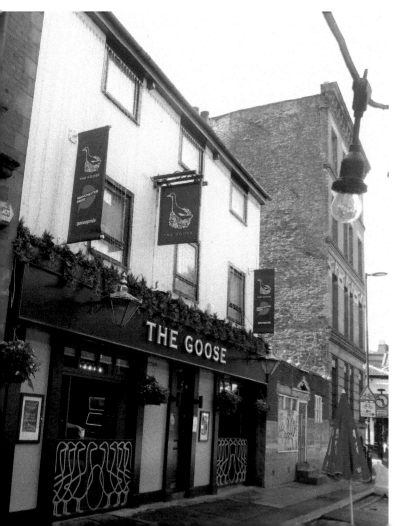

The Goose.

but by the 1960s it had become the Kingston Hotel and in 1970 it was managed by Wilsons Brewery but later in the decade it had become the Famous Paddy's Goose, managed by Watneys Brewery. The pub backs onto the Molly House and the mural on the side of this pub can be seen from the Goose. Across from the main coach station, the pub is utilised by the gay community and travellers alike in what is regarded as a traditional city centre pub.

New York New York, Bloom Street

Further along Bloom Street is the famous New York New York bar, which has for over thirty years been at the heart of the gay village and is particularly noted for its party atmosphere and drag acts. Like the Goose, it is one of the older, more traditional pubs that has been incorporated into the gay village. The pub appears to have started its life as a beerhouse at No. 98 Bloom Street and this can be traced back as far as 1850. Further evidence of the pub's existence can also be found in 1893 when it was for let and known as the New York. More recently the landlady in 2019, Tracy Walsh, celebrated thirty years at the pub, and during her time there has turned the venue into a popular place for the gay community. It is particularly noted for its cabaret, even being referred to as a party palace.

New York New York.

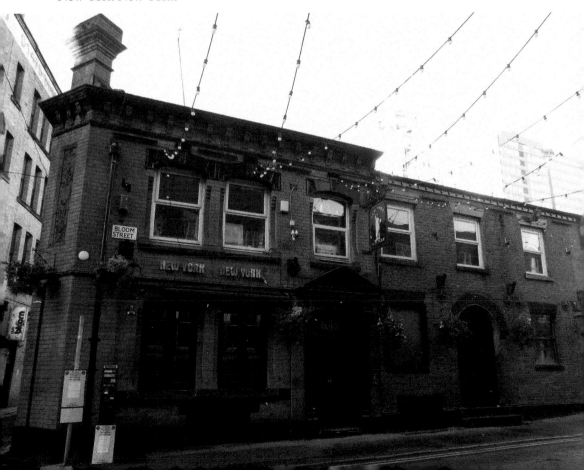

The Molly House, Richmond Street

The Molly House is a vibrant and richly decorated pub on Richmond Street. A molly house was predominantly a London phenomenon of the eighteenth and nineteenth centuries, essentially places for gay men to meet without the risk of prosecution, and it is believed that this pub, in the heart of the gay village, is named after this. A former worsted tailor's shop, the site opened as a bar in 2010. During the 1950s the building contained several businesses, including two relating to cloth and a printer's company. The pub itself is divided into a tearoom, offering a range of speciality teas and coffees, and 'bordello' on the inside, recreating a sense of decadence, and also has an outdoor veranda. As well as serving the usual beers, wines and spirits, it also provides a range of cocktails. It attracts a diverse clientele, reinforcing the credentials of Manchester as one of the most diverse multicultural and liberal cities anywhere.

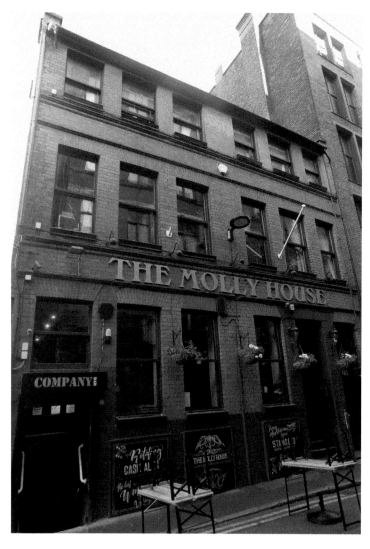

The Molly House.

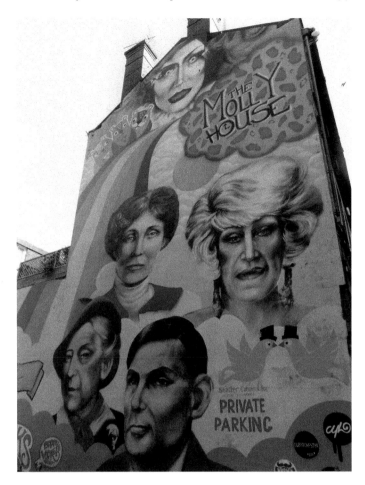

Mural on the side of
the Molly House.

The Molly House is also famous for one other remarkable feature: the side of the establishment houses one of the largest LGBT pieces of street art seen anywhere. It is a huge mural of some 40 metres high and 9 metres wide by professional Street artists Hayley Garner from Rochdale and Joy Gilleard from Leeds. The mural depicts notable figures from the area, including local drag queen celebrity Foo Foo Lammar, suffragette Emmeline Pankhurst, who fought for women to acquire voting rights, and Alan Turing, the mathematical genius who was persecuted for his homosexuality.

The New Union, Princess Street

The New Union is a Grade II listed building on the edge of the gay village and close to the Rochdale Canal. It first appears in local trade directories and newspapers from the early 1880s as the Union Tavern. Its name refers to the union of countries in the Commonwealth at that time, and stained-glass windows depict some of these countries, such as Canada, New Zealand, Australia and India. It has been a gay venue for quite some time and became the first gay establishment in Manchester, quietly accepting gay men for some time. During the Second World War the pub was a popular venue for

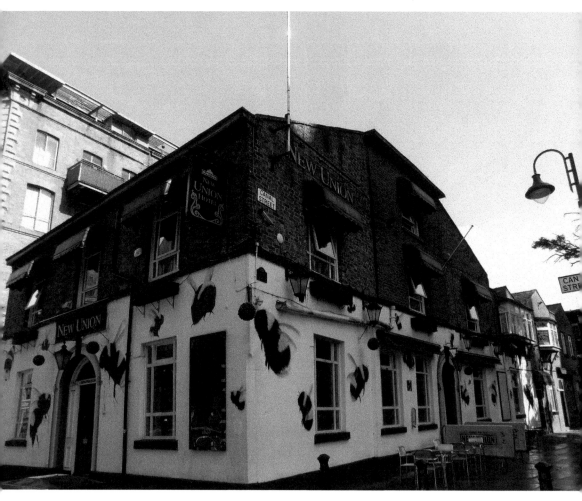

The New Union.

gay American servicemen and by the 1950s became the centre of a developing lesbian culture. In fact, during the 1950s the owner went to prison for managing such an establishment when homosexuality was still a criminal offence. Its name was changed in the 1970s to the New Union and in the 1990s was extended to cater for the volume of visitors to the pub and the gay village. A former resident of the New Union, Luchia Fitzgerald, who had run away from Ireland and came to Manchester in the 1960s, recalled how 'when they went into the pub everybody felt equally loved and cared for, but when they came out people were quite frightened for all sorts of different reasons because the police were always hanging around outside, along with gay-bashers, as they call them today'.[14] A former Wilsons Brewery pub is currently managed by Marstons Brewery.

4

Castlefield to All Saints

The Oxnoble, Liverpool Road, Castlefield

Both the Oxnoble and White Lion reside either side of the entrance to the Castlefield Roman archaeological site on Liverpool Road, and opposite the Science and Industry Museum, which was formerly Liverpool Road railway station where the first passenger journey took place between Manchester and Liverpool in 1830. The Oxnoble public house was originally known as the Cooper's Arms, and indeed it is recorded in the 1818 local directory run by a G. Mather, with its address as Castlefield, and it appears

The Oxnoble.

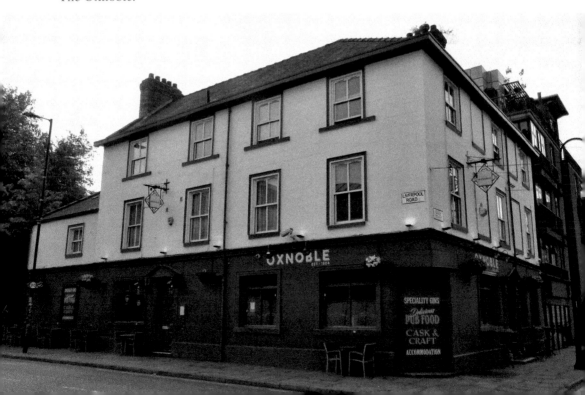

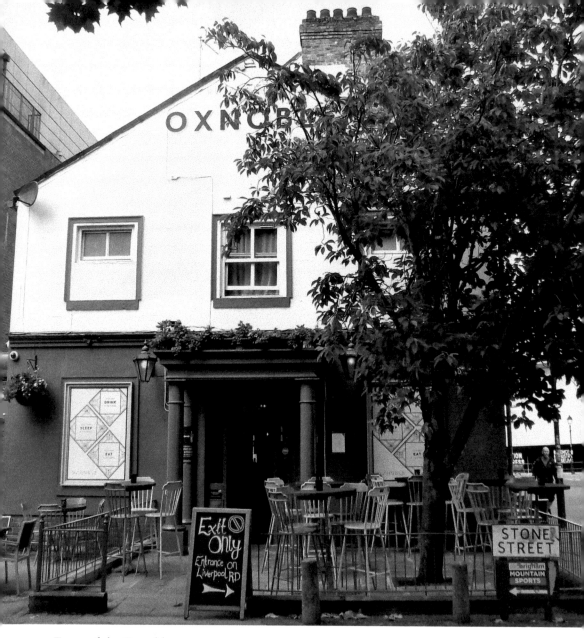

Front of the Oxnoble.

the pub was known by both names of the Cooper's Arms and the Oxnoble. By 1825 the pub was occupied by John Collins and in 1828 by Samuel Bell, but Bell moves to the White Lion in the early 1830s. The Oxnoble's name is believed to have been derived from its location near to Manchester's Potato Wharf, where the oxnoble was a variety of Georgian potato. However, the inn sign depicts a cow, and another theory indicated that the oxnoble potato was used to feed cattle and this possibly how its name originated. Others simply argue that it was named after the ox and the pub has been affectionately known as the Ox over the years. The Oxnoble was owned by Chesters Brewery from around 1911 until well into the 1980s.

The White Lion, Liverpool Road, Castlefield

Up until the early nineteenth century, Liverpool Road was known as Priestner Street and maps of the 1790s show that there were buildings at the corner of Collier Street where the White Lion is currently located, but beyond this point the area was not developed. One of the first known records of the White Lion's existence can be found in 1818, where a trade directory entry records William Hassall running the establishment with an address at Campfield. Campfield was an area noted for its markets and the first public free library in Britain. Originally the pub, like others of the time, contained a brewhouse and stables. William Hassall was still there in 1828 but by 1834 it appears that Samuel Bell from the Oxnoble public house had taken over. Into the twentieth century, the White Lion belonged to Threlfalls Brewery, which subsequently became Threlfalls Chesters, which was acquired by Whitbreads in 1967. The White Lion is popular among Manchester United fans, and its interior is adorned with memorabilia of the football club. The exterior has an area that overlooks the Roman gardens at Castlefield.

The White Lion with Beetham Tower in the background.

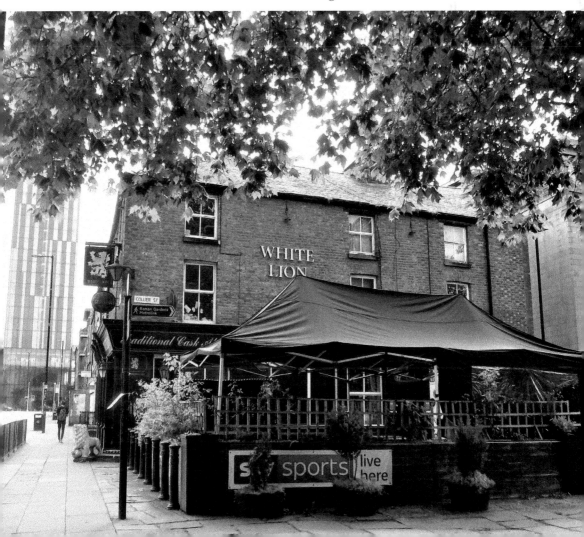

The Deansgate Tavern, Deansgate

The Deansgate Tavern was formerly known as the Crown Inn, an inscription of which can be found above the door. As the Crown Inn, we can trace its heritage throughout the eighteenth and nineteenth centuries, where one of the first records show the pub on Green's map of 1794, located on Alport Street, which eventually became the latter part of Deansgate. The local trade directory for 1794 records that the pub was occupied by Samuel Spencer, and in 1797 by James Upton. Throughout the nineteenth century it was predominantly managed by the Riley family, first by Robert until mid-century, then a younger, presumed son, Robert Riley, followed by James, and by the early 1880s a further Robert in the family. In 1860 the family were beset with tragedy when William Riley, son of former landlord Robert, was found hanged in a stable adjoining the pub.[1] The pub as the Crown Inn had an interesting past concerning local politics of the nineteenth century. For example, an article in the *Manchester Evening News* of February 1894, talks of a Peterloo veteran, Mr Jamieson, who was one of the Cavalry in the massacre and had been billeted with other troops at the Crown Inn just before

The Deansgate Tavern, surrounded by new buildings dominating the Manchester skyline.

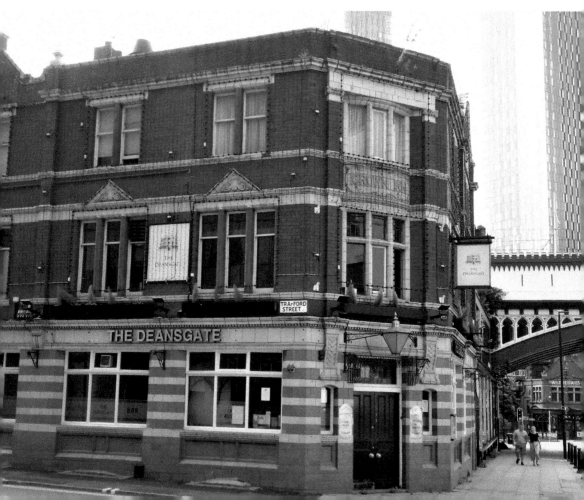

the fateful incident.[2] During the 1830s the pub had strong Scottish connections, and here we see regular meetings of the Caledonians, who met in tribute of Robert Burns, and further events in celebration of Scottish novelist Sir Walter Scott.

Formerly managed by Walker & Homfray Ltd, followed by Wilsons Brewery, following their merger with Walkers in 1949, it remained with Wilsons into the 1990s. After a spell where it was Galvin's Irish Bar, it became the Deansgate Tavern around 2009. Today the pub is dominated by the new high-rise buildings that are being erected in central Manchester, including the impressive Beetham Tower just a stride away.

The Britons Protection, Great Bridgewater Street

This unique hostelry is one of Manchester's oldest and most fascinating surviving public houses. Its name reflects its original use as a recruiting centre for locals wishing to join up for fighting and serving their country during the Napoleonic Wars in

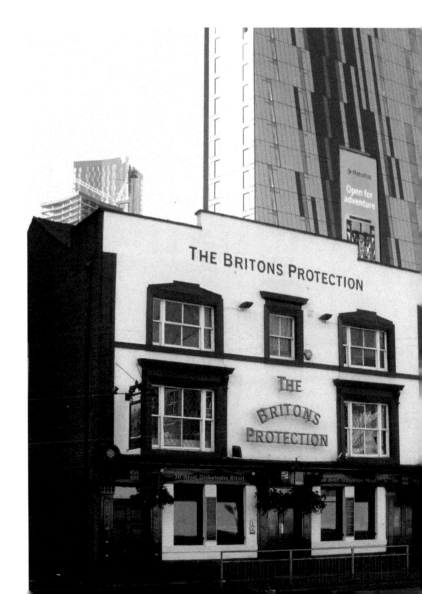

The Briton's Protection, surrounded by modern buildings.

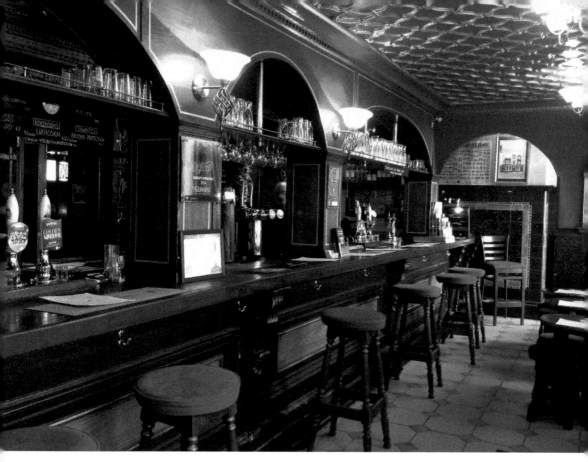

Inside the Briton's Protection. (Courtesy of Ellen Thompson)

the early part of the nineteenth century. The pub itself dates back to around 1806 (though the exterior of the pub states 1811), which is confirmed in the local press, since a January 1818 edition of the *Manchester Mercury* advertised that the pub and a piece of adjoining land were up for sale with a 1,650-year lease that was dated from 25 December 1807.[3] The pub's interior is mainly based on 1930s architecture following a refurbishment, and both its internal features and external inn sign depict scenes from the Peterloo Massacre in 1819, which took place just yards away from Great Bridgewater Street, in St Peter's Field. Here, a series of murals inside the pub depicts the horrific scenes.

Like many hostelries of the nineteenth century, the Britons Protection was used for inquests, and one example was that of the death of eighteen-year-old Thomas Cronbleholme who had died suddenly, and his inquest was held at the pub.[4] It was also a popular venue for friendly and trade society meetings that were prevalent in the nineteenth century. Here, societies such as the United Gardeners' Aid Society and the Manchester branch of the United Society of Boiler Makers and Iron Ship Builders of Great Britain and Ireland meeting to conduct business there. The pub was in the news in 1882 for the wrong reasons when the landlord, John Chapman, was charged with drink adulteration, by selling gin which had an extra 6 per cent water, and was fined 40 s.[5]

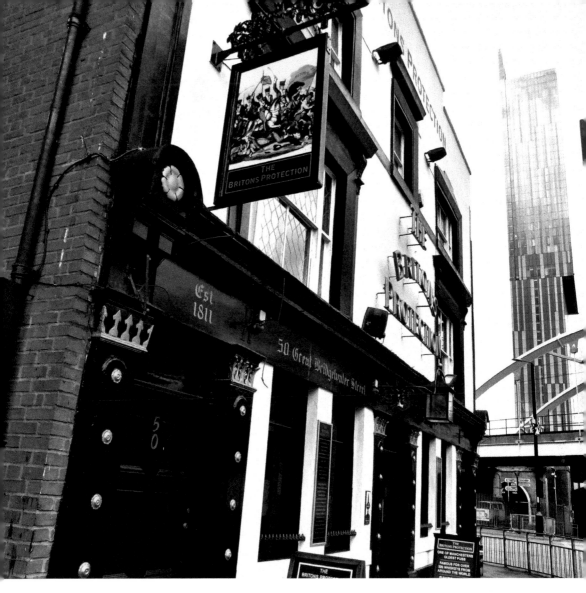

Above: Briton's Protection with Beetham Tower in the background.

Right: Inn sign at the Briton's Protection depicting the Peterloo Massacre that took place just yards away in 1819.

The Britons Protection belonged to Tetleys Brewery from the 1950s through to around 2010, and more recently managed by Heineken UK. Today, the Britons Protection is a Grade II listed building, whose proximity to the famous Bridgewater Hall makes it a popular pub for theatregoers and musicians. It is also famous for its extensive whiskey collection and is reported to have over 200 varieties to choose from. The pub was voted 'Best Pub in Manchester' in the Pride of Manchester Awards in both 2008–2009 and 2009–2010 and remains an important tourist hotspot and a heritage pub in the city.

The Rain Bar, Great Bridgewater Street

This J. W. Lees pub is a relatively recent establishment, having opened in 1999 as one of the brewery's flagship premises. However, the building itself was far removed from being a public house, having had a varied and interesting past based around several industries during the nineteenth and twentieth centuries. The popular assertion is that this was a former umbrella factory, which explains the pub's name. The umbrella factory was, in fact, a block away at No. 76 Great Bridgewater Street where the firm Occleston Greenhough had operated from around the 1860s until well into the twentieth century, still appearing in trade directories for the 1950s.

Below and opposite: Front and rear of the Rainbar.

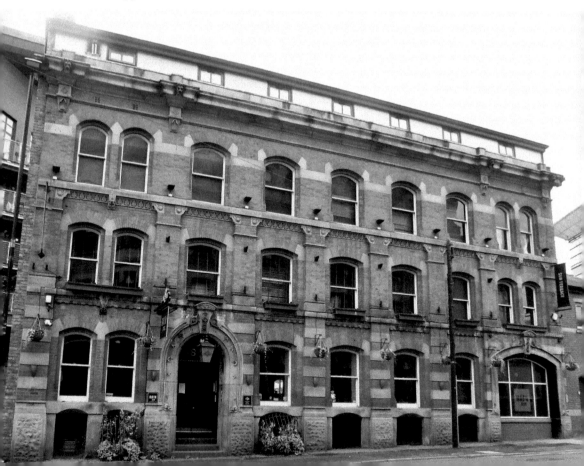

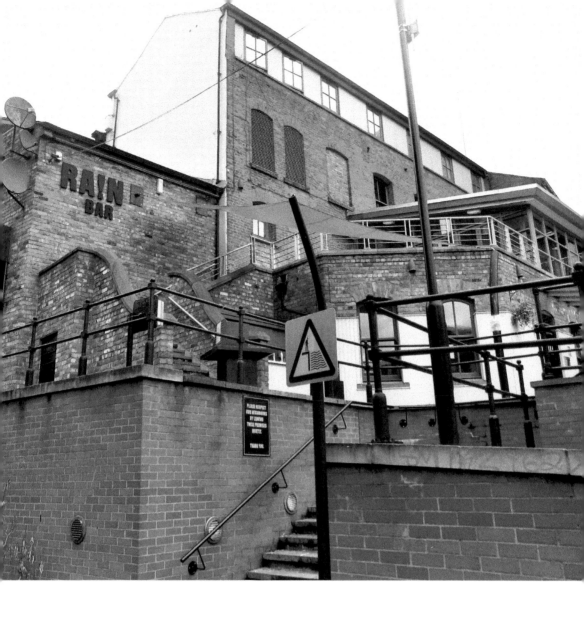

During the 1850s, the location at No. 80 Great Bridgewater Street was occupied by Crighton and Jackson's iron foundry, a weighing machine, and some offices, with Thomas Worthington's smallwares cotton mill at the rear. Worthington was still there a decade later but by November 1873 the *Manchester Evening News* reported that a Thomas Briggs was selling a factory and machinery as a cotton doubler business at No. 80 Great Bridgewater Street.[6] By the 1890s, Alexander Thomson, a chromo-lithographer and bookmaking business, had their works department at No. 80 Great Bridgewater Street, with offices at No. 8 Princess Street. The business continued there until at least 1917, but by the 1920s an artificial silk manufacturer was registered at the address under the name H. T. Gaddum. This company was still at the address in the 1950s, along with Manchester Council highways department, and the public weighing machine was still present.

During the late 1990s the building was transformed from industrial premises to a popular public house and restaurant, whose rear terrace overlooks the regenerated Rochdale Canal and modern offices and apartments that have revitalised the area.

Peveril of the Peak, Great Bridgewater Street

This Grade II listed pub, dating back to the 1820s, is one of Manchester's older and more distinctive establishments. The Peveril of the Peak dazzles with its unusual exterior, green-tiled design and odd triangular shape. In addition to its exterior tiling, the interior follows the theme through, featuring cream and green tiling with a Victorian fireplace and ornate glasswork above the bar. There are two theories to its rather unusual name. Some have contested that it was named after the Sir Walter Scott's 1823 novel of the same name. However, others have attributed it to a famous stagecoach named the *Peveril of the Peak*, running from Manchester to the Peak District throughout the nineteenth century. According to the local contemporary historian, Thomas Swindells, writing in the 1900s:

> The sign over the door of the Peveril of the Peak public house Chepstow Street was painted to celebrate its first journey, when it was drawn by six horses, with a postillion on one of the leaders. The public house was built by an old stage-coach driver named Grundy, who had previously driven one of the London coaches.[7]

The pub was redesigned around 1900 but managed to retain its original Victorian charm. More recently the Swanick family have made their mark in successfully running

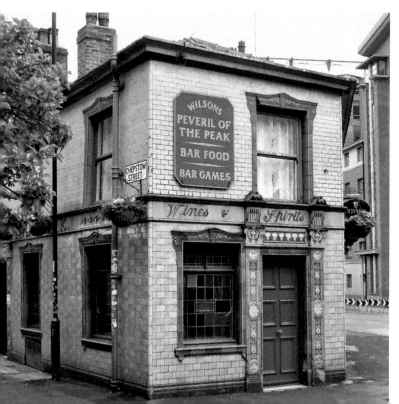

Left and opposite: The Peveril of the Peak.

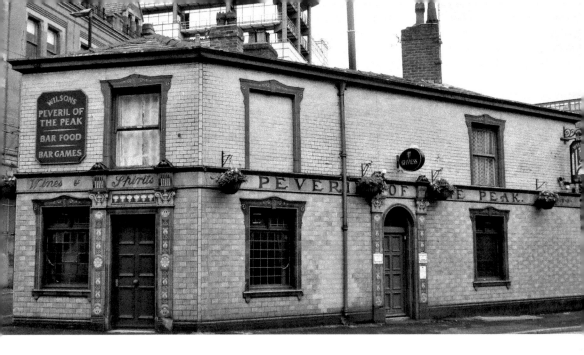

the pub. In 2011, its former landlady, Nancy Swanick, at age eighty was celebrated for running the pub for over forty years. Nancy hosted some famous names during her time since the pub was a hotspot for celebrities and sporting legends, such as actors Robbie Coltrane, *Coronation Street*'s Bill Tarmey, and former cricketer Freddie Flintoff. She met Robbie Coltrane while he was filming the series *Cracker* in 1996. Nancy was succeeded by her son Maurice, who ran the pub for a time. Both also claimed that there was an additional ghostly visitor to the pub who liked moving glasses off the bar! Despite the level of reconstruction taking place in Manchester, the Peveril of the Peak has survived demolition thanks to organisations such as CAMRA (Campaign for Real Ale) in keeping local pub heritage alive.

The Salisbury, Wakefield Street (Oxford Road Station)

The Salisbury is a quaint Victorian hostelry at the entrance to Manchester's Oxford Road station, where the railway arches dominate the building. During the nineteenth century, it was located right in the heart of the poverty-stricken district of 'Little Ireland' that was eloquently described by local businessman and Marxist commentator Friedrich Engels in his book *The Condition of the Working Class in England* that he wrote in the 1840s, where the area contained very poor Irish communities and some of the worst back-to-back housing in the region. The pub itself dates back to the 1820s and the first known record can be found in the 1824 trade directory, which reveals it to have been the Spinner's Arms occupied by James Marsh, who was still in the pub a decade later. By 1841 it had become the Tullochgorum Vaults and here it was managed by Benjamin Smith. By 1850 Kenneth Graham had taken over the pub and he could well have been the same Kenneth Graham that moved to the Lass O' Gowrie public house a few yards away in 1858, taking over from Donald Graham.[8] In 1849 it was reported in the *Manchester Courier* that an Irish bricklayer, John Driscoll, died as a result of a day-long drinking spree in the Tullochgorum Vaults and later died at the Infirmary.[9] He had reportedly

drunk spirits to excess despite having been a teetotaller beforehand. There was a bad outbreak of cholera in the city in 1849 and it suggests that his family may have been hit so hard in the conditions faced in Little Ireland he found solace in drink.

Like many pubs of the time, the Tullochgorum Vaults contained a brewhouse, which was still in operation into the 1880s. Despite its location in a predominantly Irish community, the name of the pub represented Scottish dance music. By 1895 the pub had become the Salisbury, renamed after the politician and subsequent prime minister, Lord Salisbury, under the occupation of Edward Kennedy. Into the twentieth century, the pub belonged to Wilsons Brewery, which was acquired by Watneys through their takeover in 1960, though today it is independently managed. More recently it has become a favourite haunt of commuters, students and workers alike, and is known as a rock pub, where the jukebox and clientele offer exactly that, a convivial environment for rock music.

The Salisbury with steps to Manchester's Oxford Road Station at the side.

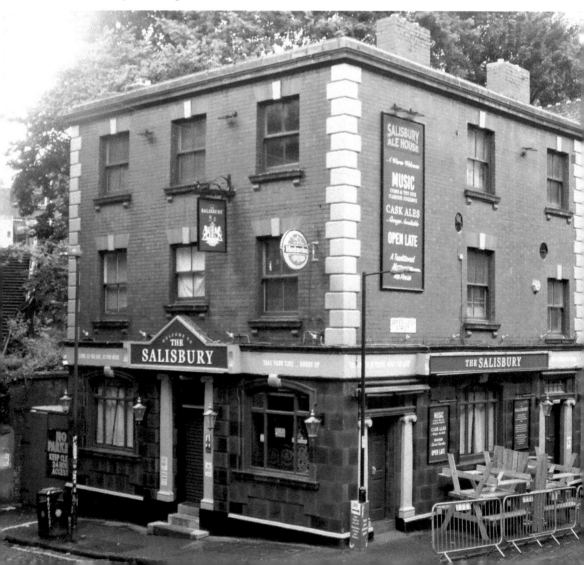

Lass O' Gowrie, Charles Street

The Lass O' Gowrie is close to Manchester's vibrant university district and consequently popular among students and staff alike. It also used to be opposite the BBC, which was located on Oxford Road, and consequently it houses memorabilia from local celebrities who used to visit the pub. This was before the Corporation moved to MediaCity in Salford Quays and the pub has suffered from this relocation.

The pub is believed to date from around the 1830s and is likely to have started its life as a beerhouse. It was originally known as the George IV and we see evidence of the pub in trade directories where, for example, in 1841 it was run by William Read, and in 1850 it was occupied by Alexander Graham. In 1853 it was still the George IV, run by Donald Graham, but by 1863 it had become the Lass O' Gowrie and occupied by Kenneth Graham, who, as indicated above, appears to have moved from the Salisbury public house a few yards away. Its name change is believed to have derived from the landlord's favourite poem, which is inscribed on the pub's exterior. The architecture of the pub includes distinctive Victorian styling, such as the exterior terracotta and brown glazed tiling. Like the Salisbury pub, its location had prominence in the nineteenth century in being close to Little Ireland and some of the poorest in the city. The Lass O' Gowrie is also famous for being the former site of a 'Pissotiere' or male urinal, which was the last known one of its kind in the city. Unfortunately, the waste found itself in the nearby River Medlock, demonstrating that personal matters of this nature were rather public affairs during the nineteenth century when sanitation was not at a premium!

Lass O' Gowrie in modern times.

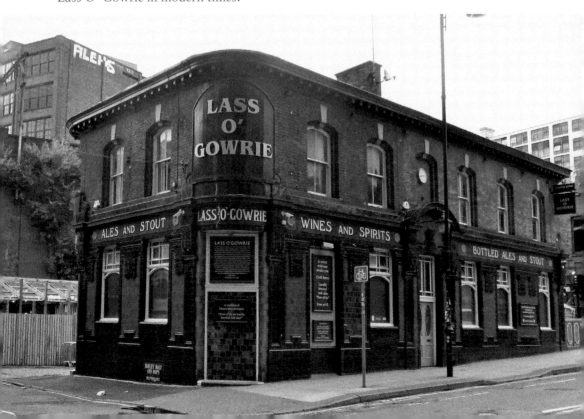

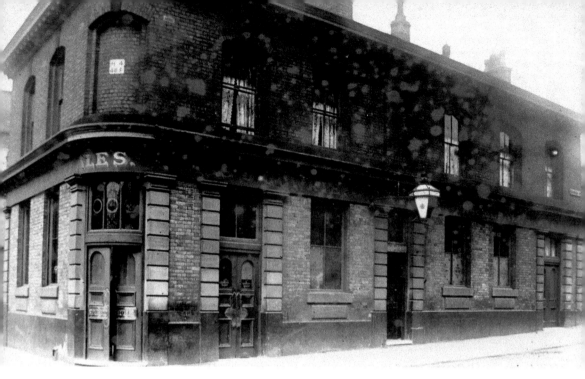

Lass O' Gowrie at the turn of the twentieth century. (Courtesy of Mark Flynn, manchesterpostcards.com)

Like many establishments of its time, the pub had an on-site brewery, which was altered around 1900. The basement is still used as a brewhouse even today. Into the twentieth century, it belonged to Threlfalls Brewery in the 1950s, followed by Whitbreads in the 1970s through a series of brewery takeovers. More recently it was acquired by Greene King. The pub still holds a traditional Victorian charm in modern Manchester and was voted the best pub in Britain in 2012, but in 2014 a dispute with the landlord, Gareth Kavanagh, led to his resignation and new management taking control and the pub underwent a refurbishment that has allowed it to retain its heritage and popularity.

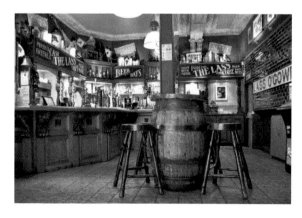

Left and opposite above: The lounge and bar at the Lass O' Gowrie. (Courtesy of Joe Gaskin)

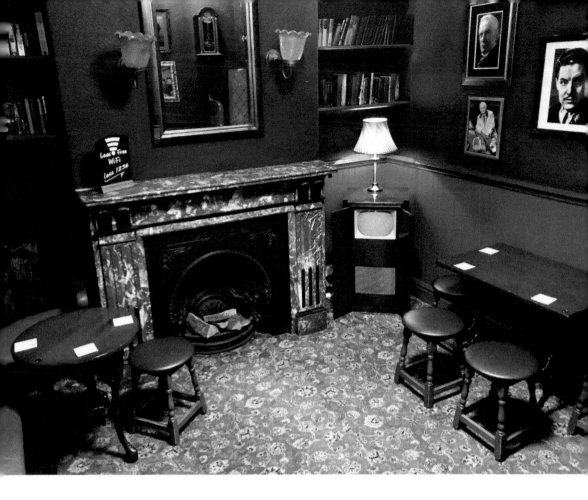

Commemorating the
oldest 'Pissotiere' in
Manchester.

The Salutation, Higher Chatham Street

The Salutation, or 'Sally' as its affectionately known, is both owned by and located at the back of Manchester Metropolitan University after the university purchased it from Punch Taverns in 2011. It reopened in 2013 and is managed day to day by the students' union. It dates from around the late 1820s, and in 1828 we know that Thomas Beverley was the landlord but by 1834 Elizabeth Beverley had taken over. In the 1820s the pub hosted a building society for the workers of the cotton mill owner Hugh Hornby Birley, whose factory was in nearby Cambridge Street. Birley is a significant figure in local history since as a local magistrate and part of the command for the Manchester and Salford Yeomany Cavalry, it is believed he had direct responsibility for sending in the troops on St Peter's field on 16 August 1819 in what became the Peterloo Massacre. The pub still contains a range of original Victorian features that date from the 1840s, with modern restorations tastefully incorporated with original architectural styling. Visitors to the pub will note a blue plaque that marks the site of former houses that were once visited by the renowned Brontë family, notably Revd Patrick Brontë and daughter Charlotte, who reportedly began writing her novel *Jane Eyre* during her visit.

The pub was a free house until it was acquired by Hardy's Crown Brewery in nearby Hulme in the latter part of the nineteenth century, and the brewery's name is still clearly displayed around the top of the building. This was covered over for some time in the 1970s when it was acquired by Tetley's Brewery, but in 2019 the pub agreed on a deal with Bollington Brewery, and the former Hardy's Brewery sign has been revealed once more in enhancing the building's original features. A final claim to fame is seen in an interior plaque commemorating the last performance by the late comedian Chris Sievey, who was more familiarly known as his alter ego Frank Sidebottom, and performed at the pub in June 2010.

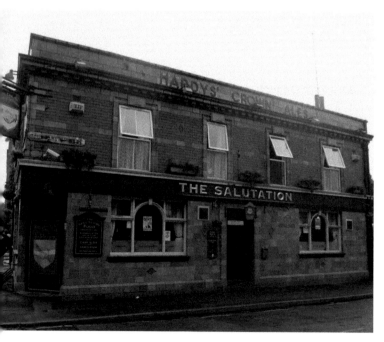

Above: Plaque on the wall of the Salutation reflecting a visit by Charlotte and Patrick Bronte to the area.

Left: The Salutation. (Courtesy of Adam Bruderer)

Notes

Chapter One

1. *Manchester Mercury*, 11 October 1808.
2. *Manchester Courier and Lancashire General Advertiser*, 8 May 1841; Kirby, D. (2016), *Angel Meadow: Victorian Britain's Most Savage Slum*, Dean Kirby, p. 90.
3. Swindells, T. (1907), *Manchester Streets and Manchester Men*, vol. 1, pp. 20–21.
4. *Manchester Mercury*, 26 January 1796.
5. *Manchester Mercury*, 28 April 1812.
6. *Manchester Mercury*, 10 August 1819.
7. *Manchester Times*, 3 November 1849.
8. *Manchester Courier and Lancashire General Advertiser*, Saturday 25 November 1865.
9. *Manchester Evening News*, 12 December 1870.
10. *Manchester Evening News*, Saturday 20 March 1915.
11. *Manchester Evening News*, Saturday 20 March 1915.
12. Dutton R., (2014) *A Tale of Two Cities: The City Pub, Oldham Street, Manchester*.
13. *Manchester Courier and Lancashire General Advertiser*, 23 December 1854.
14. Dutton R., (2014) *A Tale of Two Cities: The City Pub, Oldham Street, Manchester*.
15. *Stamford Mercury*, 16 August 1822.
16. *Manchester Mercury*, 4 October 1808.
17. *Manchester Mercury*, 16 September 1817.
18. *Manchester Mercury*, Tuesday 18 February 1806.
19. *Manchester Courier and Lancashire General Advertiser*, 18 November 1826.
20. *Manchester Mercury*, 25 February 1806.
21. *Manchester Courier and Lancashire General Advertiser*, 15 July 1882.

Chapter Two

1. *Manchester Courier and Lancashire General Advertiser*, 30 December 1901.
2. *Manchester Evening News*, 2 September 1948.
3. *Manchester Courier and Lancashire General Advertiser*, 16 June 1864.

4. *Manchester Mercury*, 25 February 1823.

5. *Manchester Courier and Lancashire General Advertiser*, 14 October 1826.

6. *The Guardian*, 12 July 2017.

7. *Manchester Courier and Lancashire General Advertiser*, 7 August 1830.

8. *Manchester Mercury*, 25 February 1806.

9. *Manchester Courier and Lancashire General Advertiser*, 26 November 1836.

10. *Manchester Courier and Lancashire General Advertiser*, 30 September 1854.

11. https://manchesterhistory.net/manchester/tours/tour2/area2page40.html

12. Earwaker, J. (1892) *Constables Accounts of the Manor of Manchester*, vol III, p. 346.

13. *Manchester Mercury*, 24 November 1778.

14. *Manchester Courier and Lancashire General Advertiser*, 16 August 1877.

15. *Manchester Courier and Lancashire General Advertiser*, 24 May 1828.

16. *Manchester Evening News*, 11 February 1882 & 8 July 1885.

Chapter Three

1. *Manchester Guardian*, 8 February 1927.

2. *Manchester Courier and Lancashire General Advertiser*, 3 December 1859.

3. *Manchester Courier and Lancashire General Advertiser*, 8 May 1829.

4. *Manchester Courier and Lancashire General Advertiser*, 7 April 1838.

5. *Manchester Courier and Lancashire General Advertiser*, 2 April 1842.

6. *Manchester Courier and Lancashire General Advertiser*, 5 January 1853.

7. *Manchester Courier and Lancashire General Advertiser*, 13 August 1853.

8. Hyde, N. (1999) *Brewing was a Way of Life: the Story of Hyde's Anvil Brewery Manchester*, p. 146.

9. *Manchester Mercury*, 3 November 1829.

10. *Manchester Mercury*, 4 May 1830.

11. *Manchester Mercury*, 26 October 1830.

12. *Manchester Courier and Lancashire General Advertiser*, 14 April 1832 & 3 May 1834.

13. *Manchester Evening News*, 24 February 2019.

14. *Manchester Evening News*, 16 July 2018.

Chapter Four

1. *Manchester Courier and Lancashire General Advertiser*, 14 July 1860.

2. *Manchester Courier*, 14 February 1894.

3. *Manchester Mercury*, 6 January 1818.

4. *Manchester Courier*, 8 June 1844.

5. *Manchester Courier and Lancashire General Advertiser*, 9 December 1882.

6. *Manchester Evening News*, 11 November 1873.

7. Swindells, T., (1908) *Manchester Streets and Manchester Men*, vol. 2, p. 230.

8. *Manchester Courier and Lancashire General Advertiser*, Saturday 26 June 1858

9. *Manchester Courier and Lancashire General Advertiser*, 22 December 1849.